LEICESTER
THROUGH TIME
Stephen Butt

AMBERLEY PUBLISHING

The former Charles Street police station, now modernised and extended and as part of the new Colton Square development.

First published 2009

Amberley Publishing Plc
Cirencester Road, Chalford,
Stroud, Gloucestershire, GL6 8PE

www.amberley-books.com

Copyright © Stephen Butt, 2009

The right of Stephen Butt to be identified as the Author of this work has been asserted in accordance with the Copyrights, Designs and Patents Act 1988.

ISBN 978 1 84868 252 8

British Library Cataloguing in Publication Data.
A catalogue record for this book is available from the British Library.

Typeset in 9.5pt on 12pt Celeste.
Typesetting and Origination by Amberley Publishing.
Printed in Great Britain.

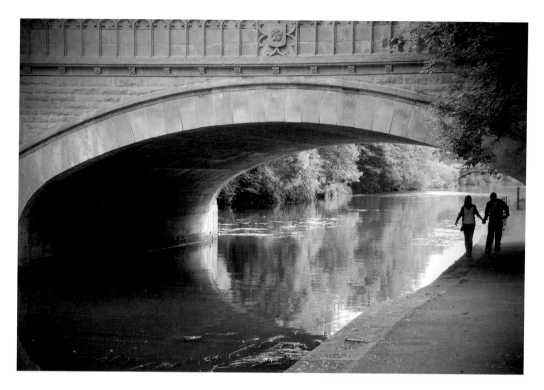

The Newarke Bridge on the River Soar, close to the Bede Island regeneration area.

Introduction

Historians and architects have been recording the changing character of Leicester and its buildings for over 3,000 years. John Nichols in his *History and Antiquities of the Town and County of Leicester* (1795-1812) listed monuments that had disappeared before and during his lifetime. In the mid-nineteenth century Dr John Barclay gave a public lecture bemoaning the lack of good new buildings, but he had changed his view somewhat when he gave another lecture some years later.

In the twenty-first century, local civic societies and heritage groups continue to express concern that new developments and regeneration projects pose grave threats to older buildings.

Yet many of the buildings we cherish today exist only because other older buildings were demolished to make way for them. The Tudor Wyggeston's Hospital in Highcross Street was demolished, despite a vociferous campaign at the time, to make way for the

Wyggeston Boys' School, which at the time of writing, is empty and awaiting redevelopment.

The Newarke Gateway, which was built in the early fifteenth century, has seen many different structures appear and disappear within its shadow. Since the closure of the Great Central Railway in the 1960s, many of the bridges, stations and viaducts on the city section of the line have been demolished, and there has been a longstanding campaign to preserve the station buildings in Leicester. However, the building of the line caused the destruction of many very old buildings in the heart of the town.

Leicester's fine architectural heritage stretches back to the Roman garrison, laid out in 48AD. This book is a celebration of both that ancient heritage and also of the new buildings that have changed the city's skyline. It is intended to stand as a record of how properly managed urban development can produce a modern cityscape which can reflect the past without turning the city into one large museum piece.

In this compilation of images of the city's past and present, there are familiar shops, landmarks and public buildings, parks and places of recreation, sporting venues and places of worship. It is intended that the reader may 'wander' through these pages in much the same way that a visitor to Leicester may explore the history and heritage of this city.

Stephen Butt
September 2009

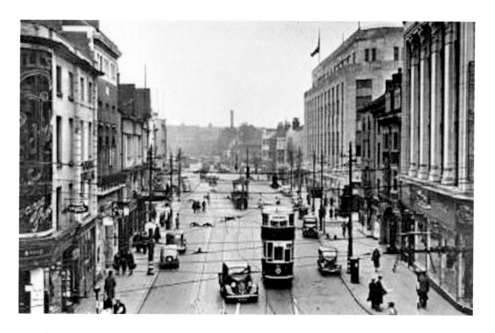

Humberstone Gate

Long before the advent of trams and motor vehicles, this was the location of the annual Humberstone May Fair which was discontinued in 1902. The dominant building in this pre-war photograph is Lewis's department store on the right. Today the area is pedestrianised and is still used as an area for street markets and entertainments. The Lewis's tower still stands.

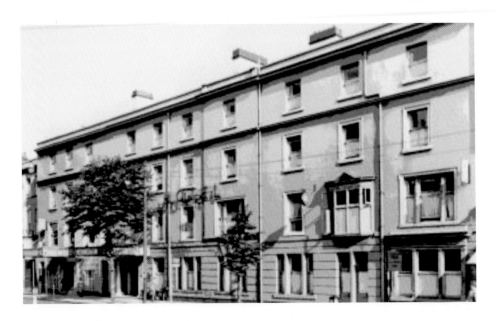

The Bell Hotel, Humberstone Gate

The Bell Hotel was built in the eighteenth century and stood on the corner of Humberstone Gate and Charles Street, a central location in the town. Many societies met here over the years including the Caledonian Society and the Leicester Magic Circle. Businessmen met at The Bell too, and it was here in 1830 that they agreed plans for Leicester's first railway line, linking the coalfields to the town. The hotel was demolished in the 1960s to make way for the Haymarket shopping precinct.

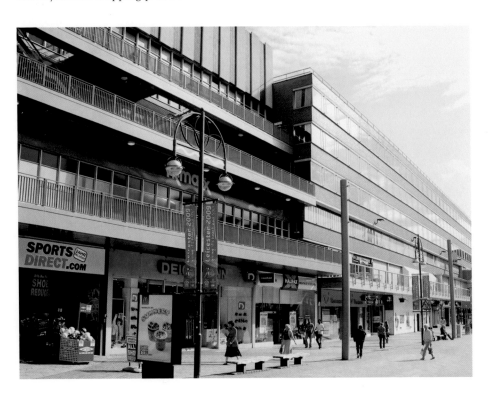

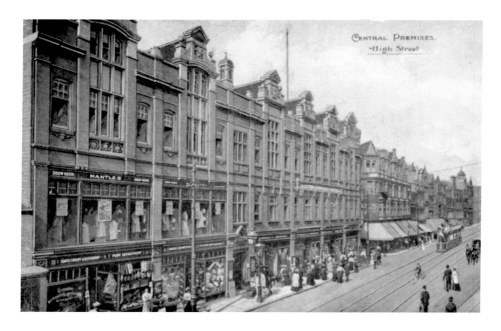

The Co-op, High Street

Leicester has had a long association with the Co-operative movement, and this popular and rambling department store was a favourite shopping focus for local people for many years. It was designed by Thomas Hind as the Centre Store and offices of the Leicester Co-operative Society, and opened on 10 November 1894. Several extensions were added in later years. The frontage was retained when the Shires shopping centre, now the Highcross Centre, was developed in 1989.

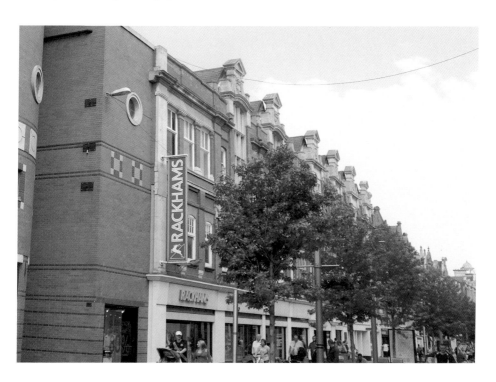

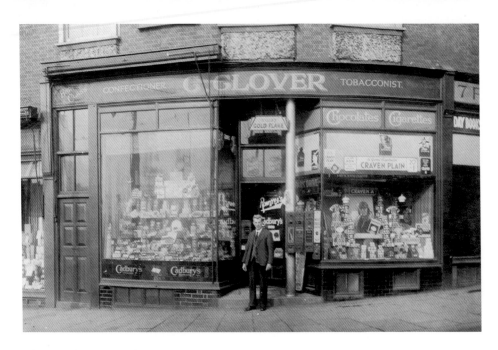

Glovers Shop, 5 Applegate Street

The section of the present St Nicholas Circle from Bath Lane to Talbot Lane follows approximately the path of the former Applegate Street. These shops faced in the direction of where the Holiday Inn stands today. Next door at no. 7 is Ferneyhough & Sons, printers. Mr Glover's shop stood approximately between the road sign and the traffic light in the modern photograph. The no entry sign on the far left marks the corner of Bath Lane; the corner of Talbot Lane is on the far right.

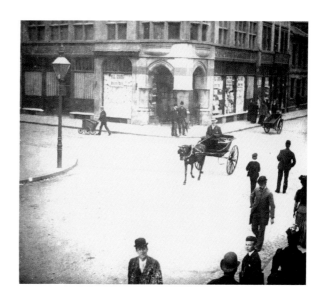

Joseph Johnson's, Belvoir Street

Entrepreneur Joseph Johnson owned several businesses in Belvoir Street, from drapery to funeral undertakers, and finally decided to put them all under one roof. This early photograph was taken in about 1897. The building was designed by the Leicester arts and crafts architect Isaac Barradale. It is typical of his 'Leicester Style', with tall gables, rough cast walls, heavy timbering and small-paned windows. Johnson sold the building to Fenwicks in the 1950s. Although the interior of the store has been restructured — a fine staircase was demolished — the exterior is much as Barradale intended.

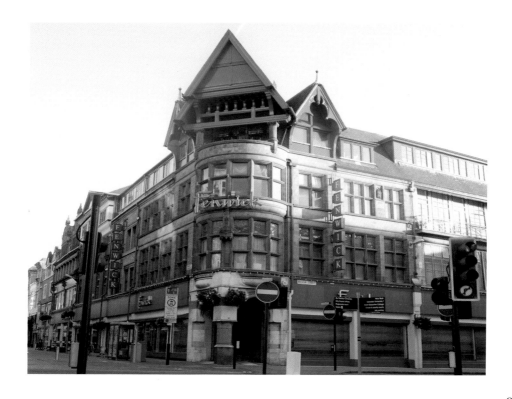

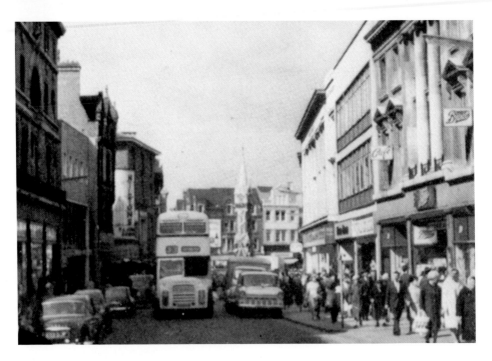

Gallowtree Gate Towards the Clock Tower

A view of Gallowtree Gate when buses, cars and pedestrians jostled for space. As early as 1920, traffic congestion caused the Corporation to plan a bypass which resulted in the creation of nearby Charles Street. Today, modern landscaping and pedestrianisation has changed the atmosphere entirely. Leicester City Council won the Urbis Urban Regeneration Award in 2007 for its redesigning of the area.

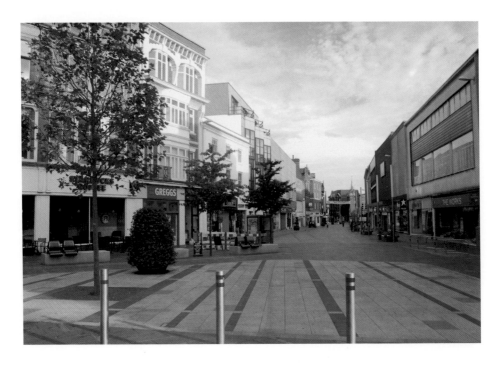

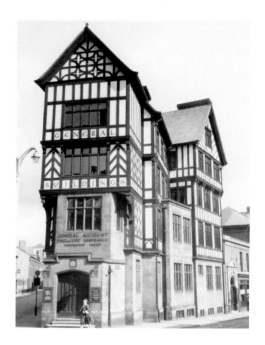

The General Building, Wellington Street

Though not a particularly old building, the former General Building at the junction of Wellington Street and King Street adds character to the area. It was home to the General Life and General Accident insurance companies and, in more recent years, to the social club for Leicester City Council staff. It is now a nightclub, offering a different type of music on each floor.

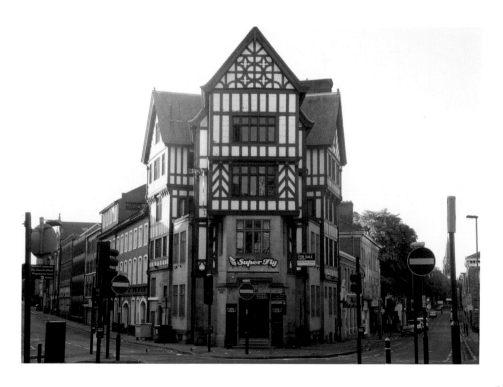

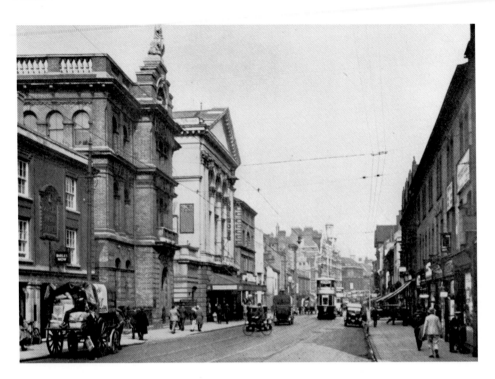

Granby Street
The view down Granby Street towards Gallowtree Gate. The present view is taken from where the tram is standing in the older photograph.

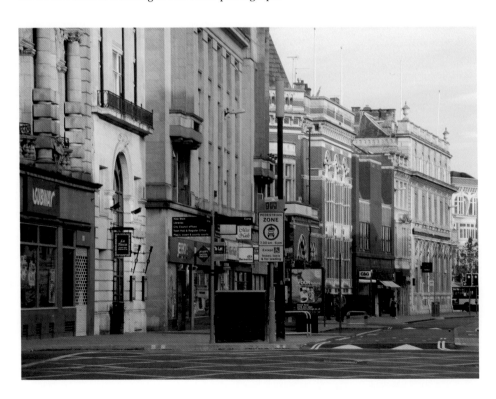

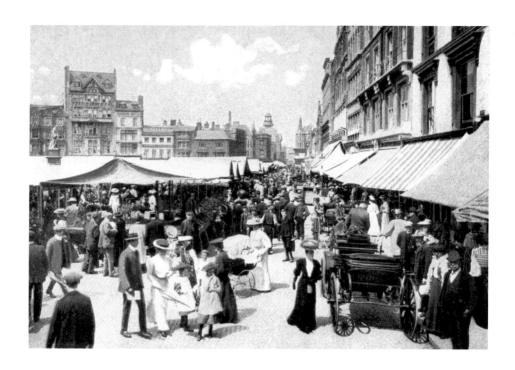

The Market Place
Formerly the Saturday Market, traders have stood on this site for at least 700 years. It was originally more extensive, with specific areas set aside for selling meat, fish, livestock, horse-drawn carriages and agricultural equipment.

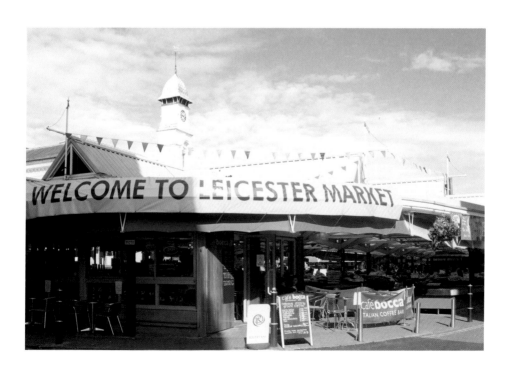

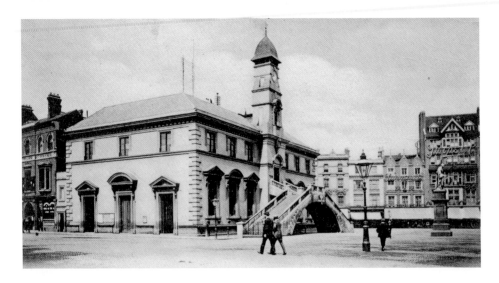

The Corn Exchange

There have been public buildings on this site since at least 1440 when the first Market Hall was constructed by the Duchy of Lancaster. The present elegant building was designed by William Flint in the 1850s, with the upper floor and distinctive rusticated open bridge added by F. W. Ordish in 1856. After a fire in the 1980s, which gutted the interior of the ground floor, the building lay empty for some years. The most recent redesigning of the market square has enabled a better view of the frontage. The square makes an ideal area for modern public performance. In the past, political rallies and religious meetings were held here; today it is an arena for entertainment during the annual British Market Week.

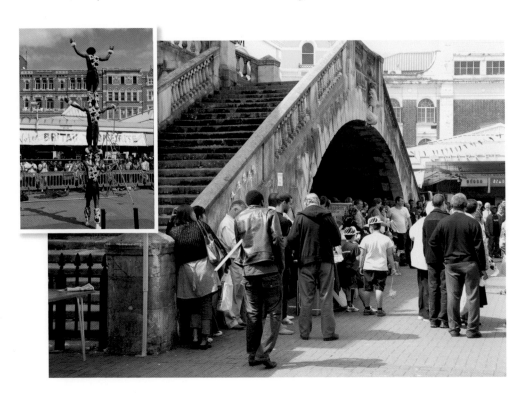

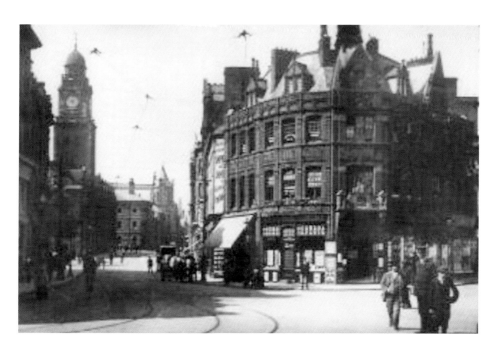

Market Approach and Horsefair Street

The atmosphere and character of this important city landmark has changed little since Victorian times. To the left are Horsefair Street and Town Hall Square; to the right is Leicester's famous ancient market. The current building occupying the space between has remarkable similarities in design with its predecessor.

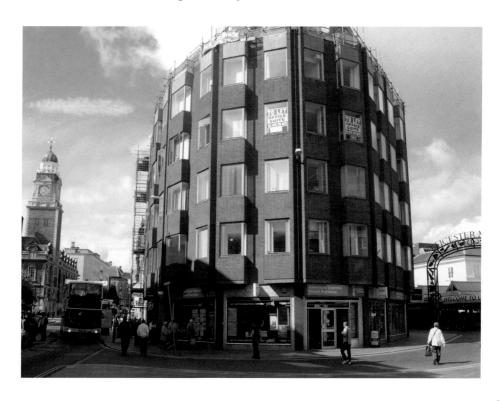

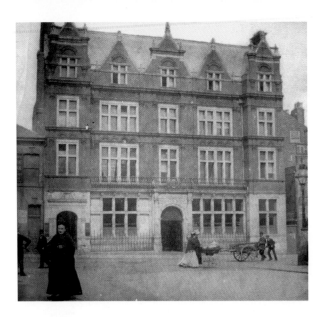

Alliance Chambers, Horsefair Street

The frontage of the Alliance Chambers in Horsefair Street, facing Town Hall Square, has changed little in the hundred years that separate these images, except for the loss of the railings above the ground floor façade. In 1985 the Alliance Building Society and the Leicester Building Society merged to create today's Alliance and Leicester group. The building still serves as a bank, now owned by Santander.

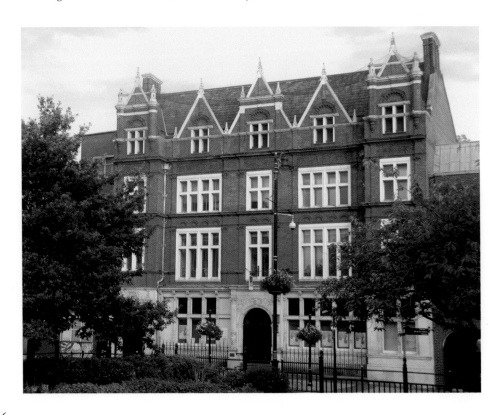

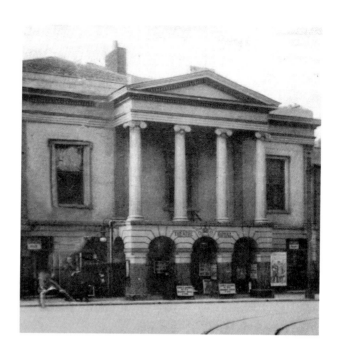

The Theatre Royal

The Theatre Royal was a well-designed theatre that occupied a site with its frontage on Horsefair Street, almost opposite Bowling Green Street and the side of the Town Hall. The stage door was on Market Approach near to the Fish Market. It was built in 1836 on the site of an earlier theatre, and for some years was the town's only theatre. It closed in 1958.

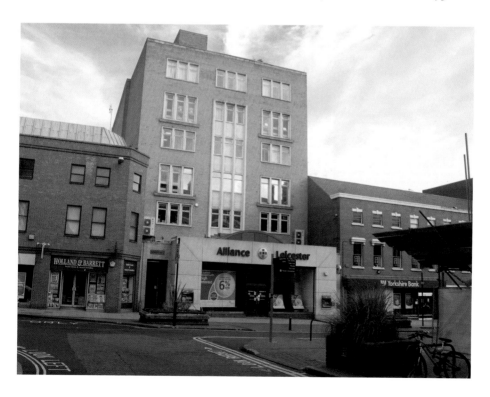

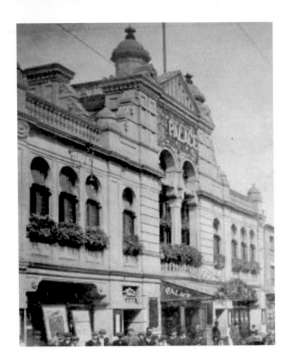

The Palace Theatre

This early image of the Palace Theatre in The Haymarket was taken in 1907. It opened in 1901 and could seat 3,000 people. It was demolished in 1959. Sixty years later, retail shops with familiar names occupy this area, but it cannot be said that the quality of the architecture has improved.

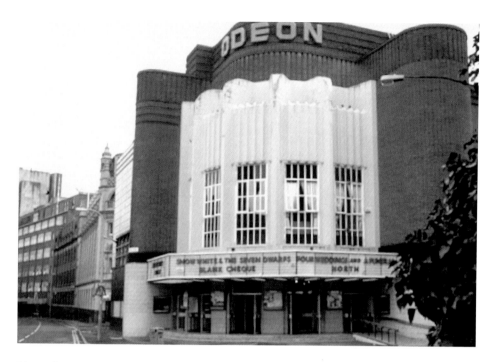

The Odeon, Queen Street

The Odeon Cinema in Queen Street opened on 28 July 1938. It was designed by Norman Bullivant who was on the staff of the Birmingham architect group of Harry Weedon which designed all the Odeon cinemas. The first film to be screened in its 2,000-seat auditorium was *A Slight Case of Murder* starring Edward G. Robinson. The cinema closed in 1997, the day before the new Freemen's Common Odeon Multiplex opened. After lying empty for several years, it has been carefully restored and given a new lease of life as the Athena Conference and Banqueting Centre. This photograph was taken in 1994 when the cinema was operating four screens. Today, despite its powerful design, it is dwarfed by Curve, Leicester's new theatre complex.

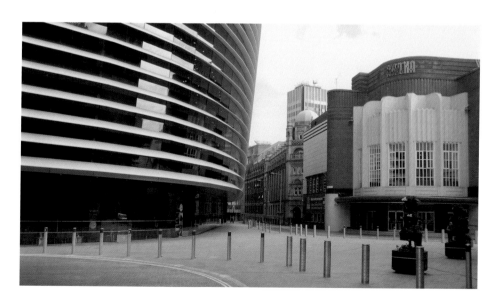

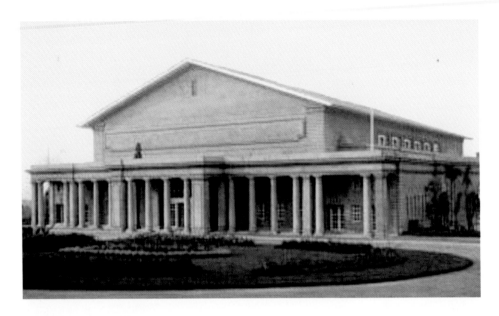

The De Montfort Hall

The De Montfort Hall was built by the Leicester firm of Stockdale Harrison in 1913. They created a building which seems virtually timeless in design. It has certainly faced up to the rigours of changing tastes in entertainment having been a venue for classical music, boxing, fashion shows and pop concerts. Today, the hall hosts 'Summer Sundae' one of the finest music festivals in the UK, as well as providing a rich programme throughout the year of diverse artistic events. A major refurbishment took place in 1994, and the hall is now as fresh and as new as the day it was built. The magnificent organ — the only surviving example of a concert organ by the Leicester organ builders Stephen Taylor and Sons — was donated to the hall by Alfred Corah of the Leicestershire textile family; in 2004 it was fully renovated.

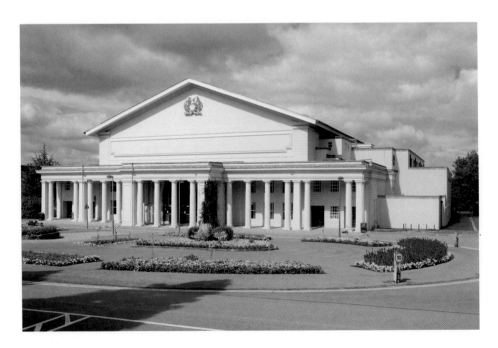

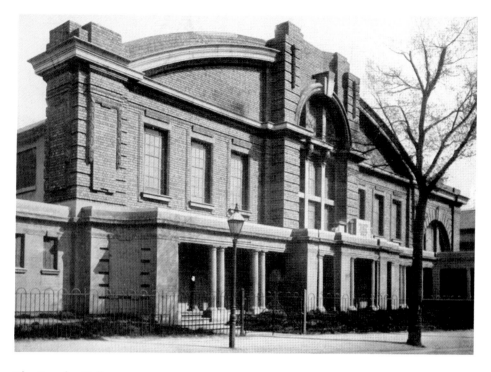

The Granby Halls

Much loved and much maligned, the Granby Halls were immensely popular with generations of Leicester people. The origins of the two halls, with its connecting passageways and ancillary buildings, seem shrouded in the mists of time but were first used as a military base. The new Tigers stand on the adjacent Welford Road ground overshadows the site of one of the former halls.

Inset: All that remains of the Granby Halls today is this small, miserable building facing Oxford Street, which houses electricity transformers.

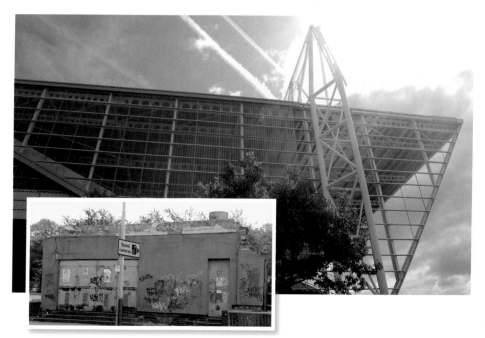

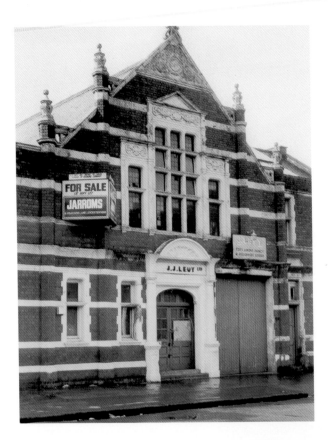

The Lyric Cinema, Clarendon Park Road

The Lyric was one of the many silent picture houses situated in the urban communities just outside the town centre. The proprietor decided not to convert his picture house to sound when the technology became available and as a result the cinema failed. For many years this building was used as a warehouse for local businesses. Today it is the smart and well-appointed centre of the Chinese Christian community in Leicester.

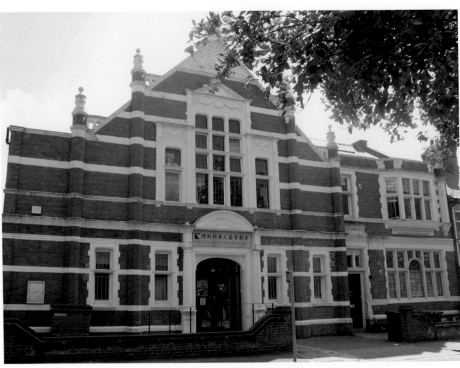

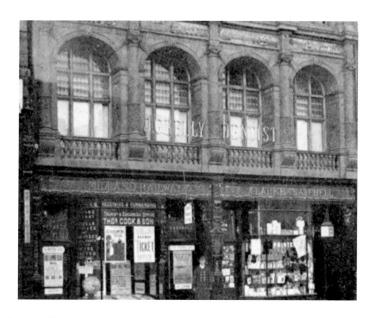

The Thomas Cook Shop, Gallowtree Gate

The former Thomas Cook office in Gallowtree Gate was designed by Joseph Goddard in 1894. It was built by Thomas' son, John Mason Cook, two years after his father had died. Above the first floor windows are four terracotta panels showing the firm's history during Thomas's tenure from 1841 to 1891.

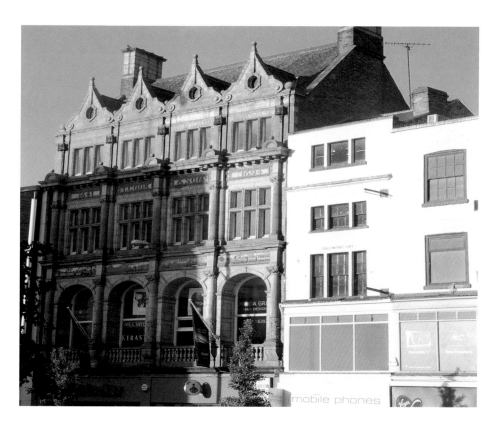

Thorncroft, 244 London Road

Thorncroft is the house that Thomas Cook built for his retirement in 1875. In architectural style it is quiet and unassuming. The name Cook chose for the house is said to be a cryptic play on 'Quick Close', which was the street in Melbourne where he was born. The 'quick thorn' is a form of Midland Hawthorn and the word 'croft' can be used as a simile for 'close'. Thorncroft is now the headquarters of the Leicestershire branch of the British Red Cross Society.

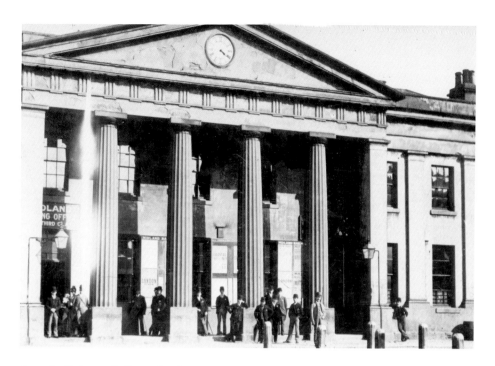

Campbell Street Railway Station

This was the first railway station to be built on this site and it was certainly the most imposing. It was opened on 4 May 1840. A large classical building, eleven bays wide with a giant portico of six Tuscan columns carrying a pediment. It was a truly majestic building, demolished prematurely due to competition between railway companies. Today the various elements of the St George's Complex, formerly buildings owned by the GPO, dominate Campbell Street. Inset: At the end of nearby Station Street are two Egyptian-looking gateposts which are the only surviving features of the original railway terminus.

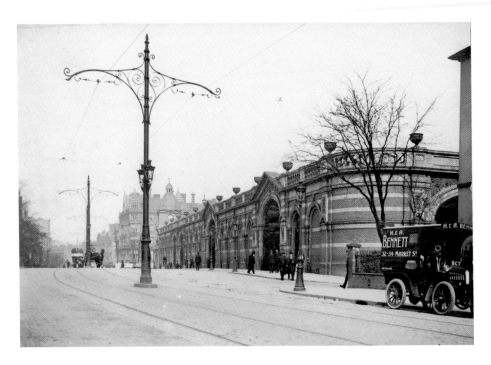

London Road Railway Station

One of the warmest and most welcoming stations on the Midland Railway, Leicester's London Road station was designed in 1892/4 by Charles Trubshaw. Today, its once imposing frontage (the gates were designed and constructed by the local firm of Elgoods) is overshadowed by the high-rise developments of the 1970s. The station clock is the only hand-wound station clock in the UK.

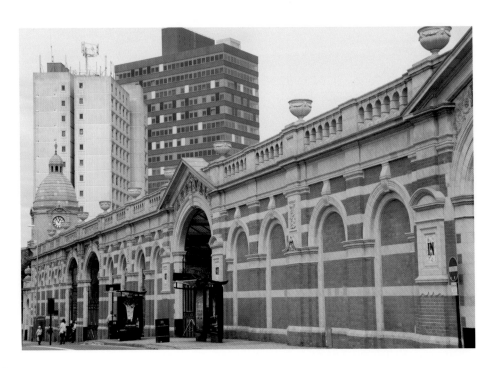

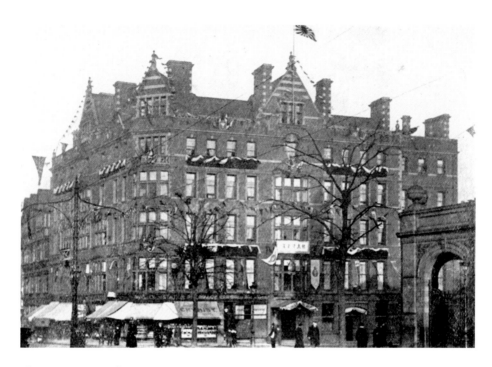

The Wyvern Hotel

The Wyvern Hotel was constructed less than a year after the neighbouring railway station was opened, and signified the new world of travel by rail, created in part by Thomas Cook. His statue stands close to where passengers once walked en route from the station to the hotel. It was designed and created by James Walter Butler, RA. Cook's long association with Leicester began in July 1841 when he arranged for a party of local temperance supporters to travel by train to a rally at Loughborough. In the autumn of that year he moved to the town. St Stephen's church, now in New Walk, was originally built on this site, and was moved, stone by stone, to make way for the hotel.

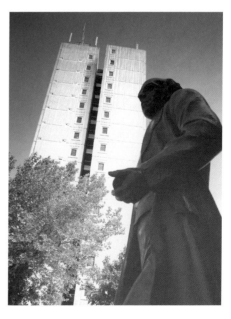

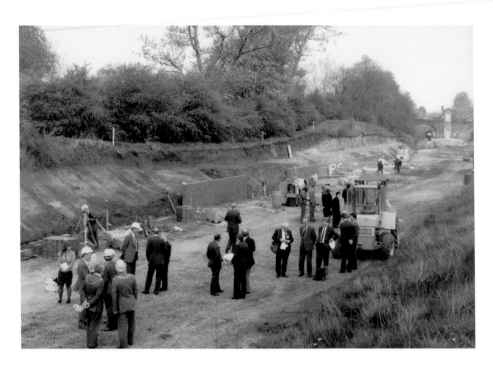

Leicester North on the Great Central Railway
An image from the 1980s of the track bed being cleared in readiness for the building of Leicester North, the new terminus for the Great Central in Leicester. The station opened in 1991 and the buildings were completed in 2002. The new canopy, at a cost of £60,000, was 'opened' on 6 August 2009. In the distance is the bridge carrying Station Road into Birstall where the demolished Belgrave and Birstall station formerly stood.

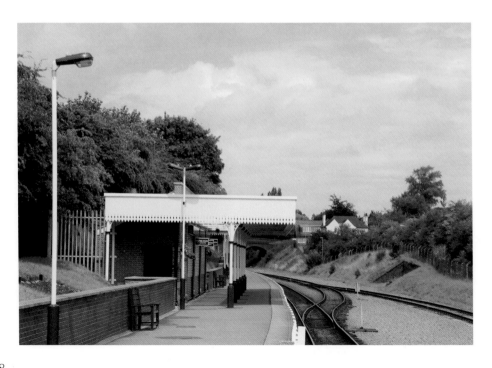

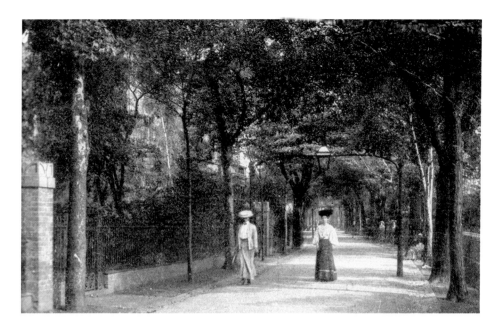

New Walk

The character of New Walk, laid out in 1785 on the route of the Roman Gartee Road, has hardly changed since these ladies took their afternoon walk except for the litter bins and CCTV cameras which are so much a part of today's street furniture. Leicester City Council caused controversy when it adopted the New Walk Centre, at the junction of New Walk and Belvoir Street, as its administrative headquarters. The fifteen-storey building, standing 55 metres above ground level, had been built by a speculative developer who had then been unable to find tenants.

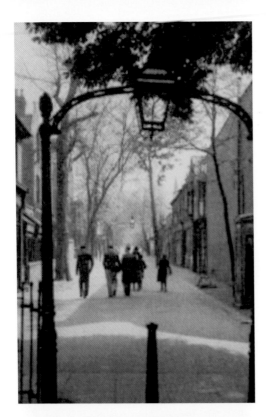

New Walk Entrance
The lower entrance to New Walk, popular with local workers as well as visitors to the city, with cafés, restaurants and clubs now lining this historic path. Although the street furniture is of the twenty-first century, it has been designed to enhance the historic atmosphere of the area.

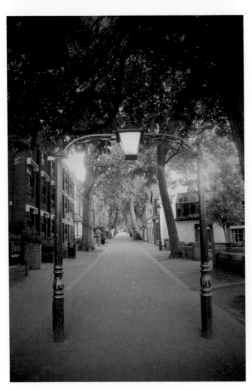

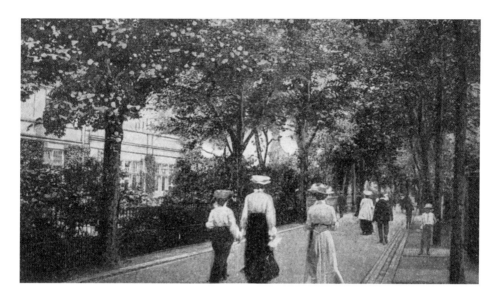

New Walk Museum

There is an air of Edwardian elegance in this picture of local people enjoying the tranquillity of New Walk. The museum was built in 1837 as a Nonconformist proprietary school from the designs of Joseph Hansom, the Hinckley-born inventor of the Hansom Cab. It became a museum in 1849 when the Leicester Literary and Philosophical Society formally presented its various collections to the town, forming the nucleus of the collections on display today. New Walk Museum has been the inspiration for many people including Lord Attenborough and Sir David Attenborough, who developed their love of art and natural history as a result of frequent childhood visits to the galleries.

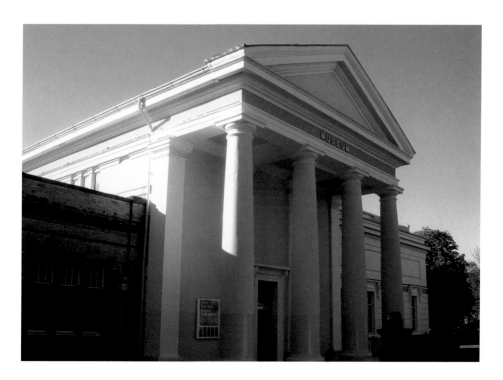

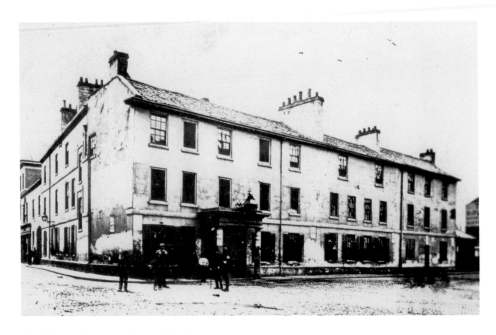

The Three Crowns, Horsefair Street

One of Leicester's famous and historic hotels located in the heart of the nineteenth century town at the junction of Gallowtree Gate, Granby Street, Horsefair Street and Halford Street. This photograph was taken in 1860. The National Westminster Bank which replaced it is in itself a dignified building, and stands in a prominent position at the end of the remodelled and pedestrianised Gallowtree Gate.

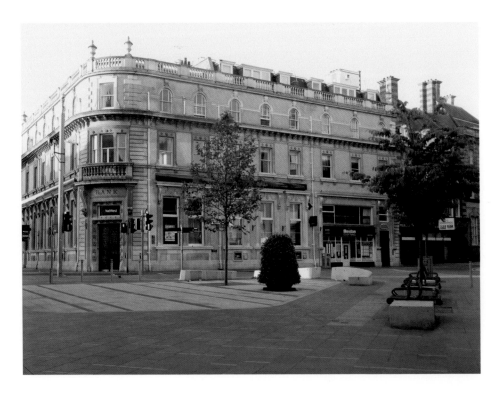

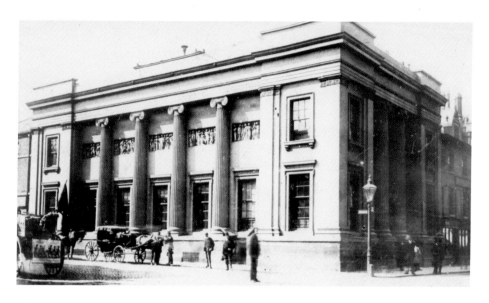

The General Newsrooms

Samuel Lewis, in his *Topographical Dictionary of England* writes 'a very handsome edifice was erected in Belvoir Street in 1837 as a general newsroom and library, at an expense of about £6,000, from the designs of Mr Flint; it contains a gallery for the library, and committee-rooms, and apartments for the librarian'. This remarkable building dominated the approach to the centre of the town from the south along Granby Street. It was demolished in 1896 as part of 'street improvements'. The present building, on the corner of Belvoir Street and Granby Street, was built in 1898 and was certainly impressive in its original form before modern shop fitters replaced the ground floor. It was designed by Goddard, and has reliefs of the Nine Muses along the third storey.

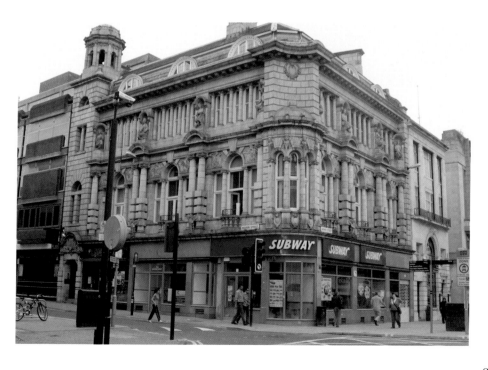

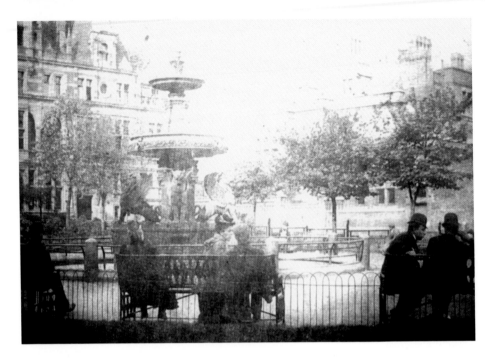

The Town Hall

This is a building with a quiet eloquence, and unlike many similar buildings in other major cities, does not stand at a major road junction or in the busiest part of the city. Leicester Town Hall was designed by Frances Hames and constructed between 1874 and 1876. The building and Town Hall Square occupied the site of the town's former Horse Fair.

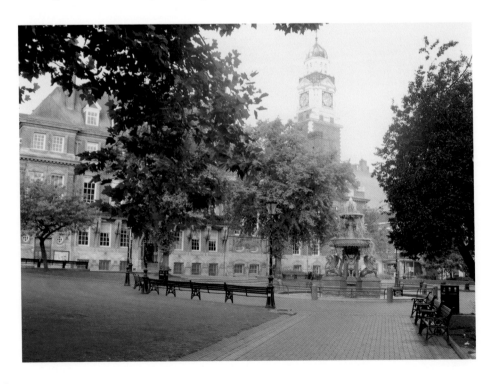

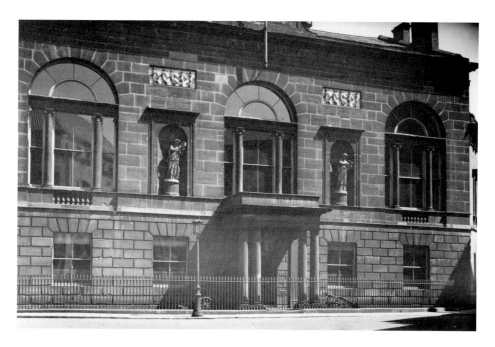

The County or City Rooms

The City Rooms — as the building is known today — was constructed in the eighteenth century as a hotel but was never used for that purpose. For many years it was owned by Leicestershire County Council who later exchanged it for rooms in the annex of the Museum and Art Gallery owned by the City Council. Today it is a popular venue for wedding receptions and banquets. One of Leicester's most delightful works of public art by the artist James Butler, a young woman sewing, stands outside.

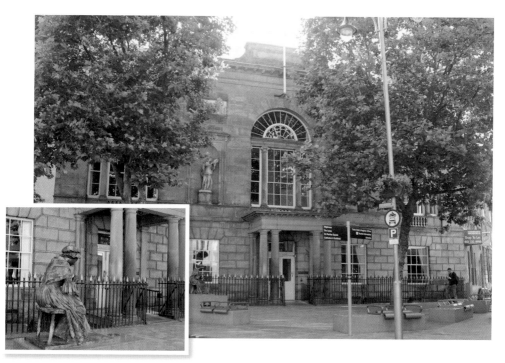

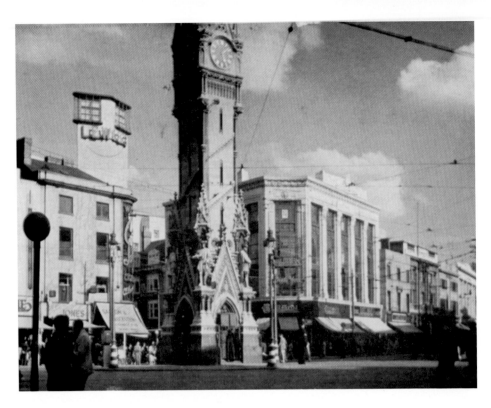

The Clock Tower and Humberstone Gate

Looking beyond the clock tower, it is the Lewis's Tower that dominates in this view of the junction of Humberstone Gate and Gallowtree Gate. The architectural historian Pevsner wrote of the tower that was built in 1935/6 and faced in Portland stone: 'definitely not in good taste, but by its very queerness and uncouthness an established landmark'. The design was by G. de C. Fraser, the Liverpool-based architect who also designed buildings for the Littlewoods Group.

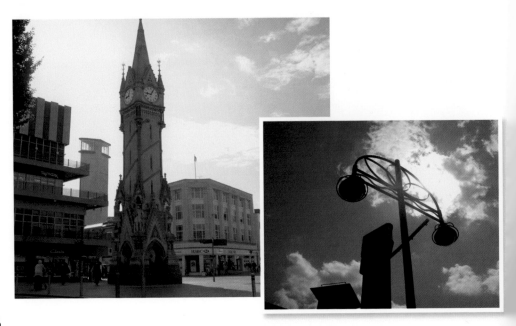

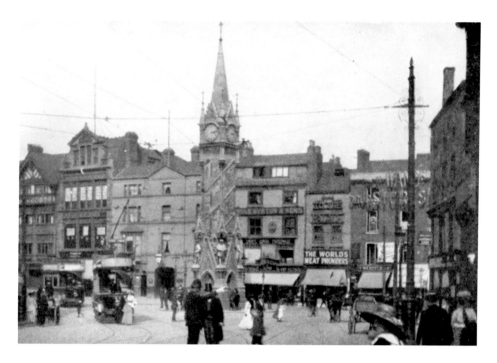

The Clock Tower and the Haymarket

Another view of the clock tower but from a different perspective, this time looking towards the Haymarket area and the shop frontages of 1910 between the Haymarket and Gallowtree Gate. The Haymarket Centre replaced these shops in the 1960s and was itself refurbished in the 1990s.

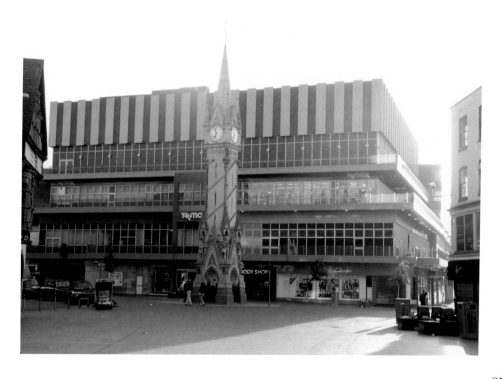

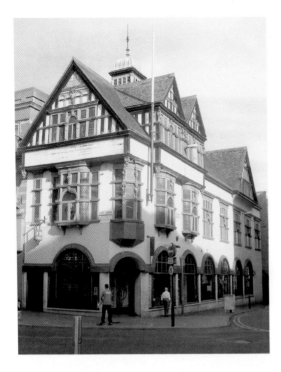

The Clock Tower, Churchgate and Eastgates

The Eastgates Coffee House on the corner of High Street and Churchgate was opened by the Duchess of Rutland on 15 June 1885, described as 'built in the domestic style of the fifteenth century and both internally and externally much admired'. The Leicester Coffee and Cocoa House Company had been formed in 1877 with the object of providing alternative forms of refreshment to alcohol.

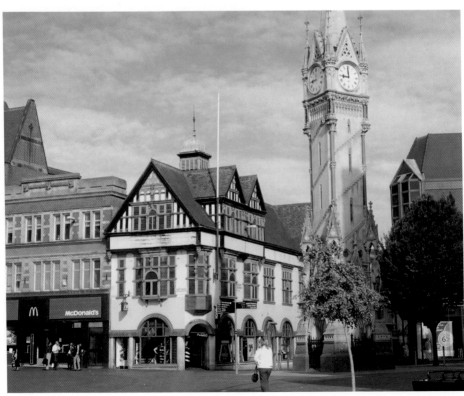

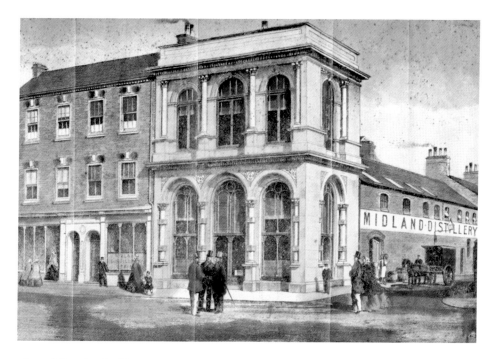

The Midlands Distillery, Humberstone Gate

J. Meadows advertised himself as a gin and brandy distiller, but the Midlands Distillery on the corner of Humberstone Gate and Clarence Street was really a wine and spirits warehouse. It was later used by the wine merchants, Challis and Allen, and by Greens, the electrical retailer. It is still in use today as a retail shop and, after some years of neglect, the impressive Victorian frontage has recently been refurbished.

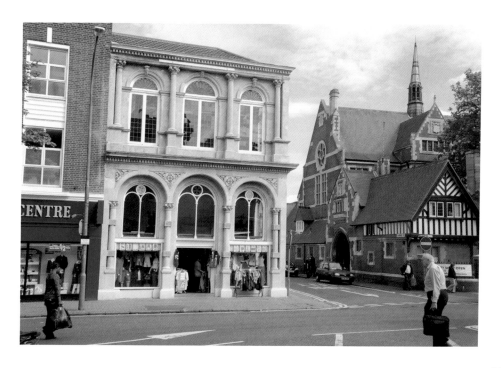

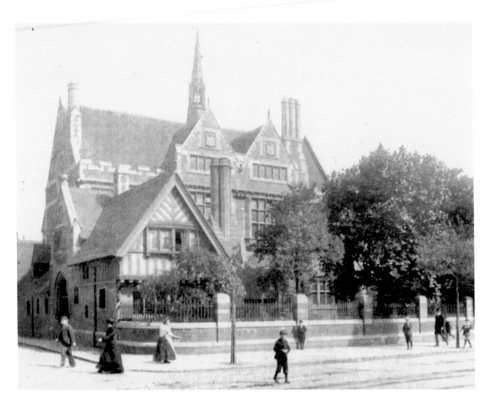

Wyggeston Girls' School, Humberstone Gate

Edward Burgess designed this school, which was opened as the Wyggeston Hospital Girls' School in 1878. Miss Ellen Leicester was the first headmistress, and on the opening day there were 150 pupils, taught by four assistant mistresses. The school moved to new premises in Regent Road (now Regent College) in 1928 and in its place the City Boys' School moved in from the Great Meeting school building in East Bond Street. In the years leading up to 1974 when Leicester achieved unitary status, the buildings became redundant. It is said that an 'eleventh-hour action' in applying for listed building status prevented their demolition and enabled their sale to Age Concern Leicester which makes good use of the premises today.

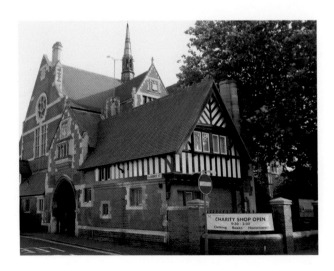

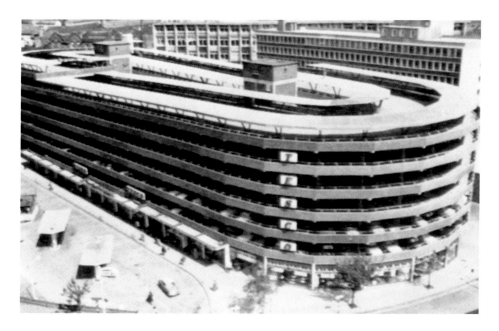

The Lee Circle Car Park

Time and the weather have not been kind to the Lee Circle car park. Built in 1965, it was the first automatic multi-storey car park in Europe and it housed, at the time, the largest supermarket in the UK, the first Tesco outside London. In fact, it is a fascinating architectural feature with a 'double helix' spiral and two entrances at ground level to two totally separate car-parking areas. It now looks run-down and out-dated, and in 2008 Leicester City Council announced plans to demolish it, prompting a campaign to save the building as part of Leicester's heritage.

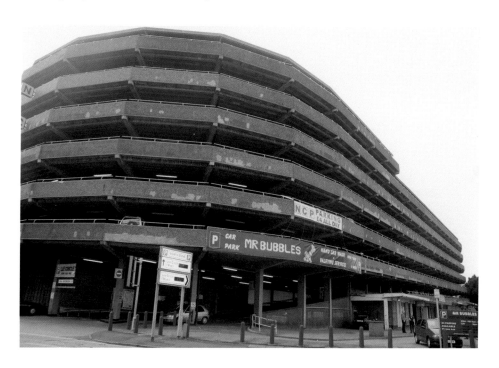

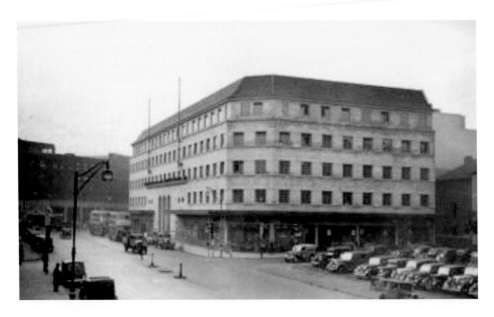

The Municipal Buildings in Charles Street

There is an air of confidence and assurance in the design of this building, a form of 'municipal tranquillity', but also a sense of anonymity. Charles Street was created in the 1930s as a bypass for the congested clock tower area and was opened on 16 June 1932, the same day that the first performance of the famous Leicester Pageant took place. Charles Street has now also been bypassed. Beneath one section of the building is a nuclear shelter, part of the city's contingency plans during the Cold War period.

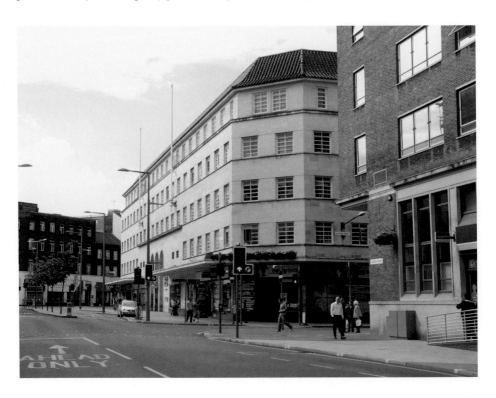

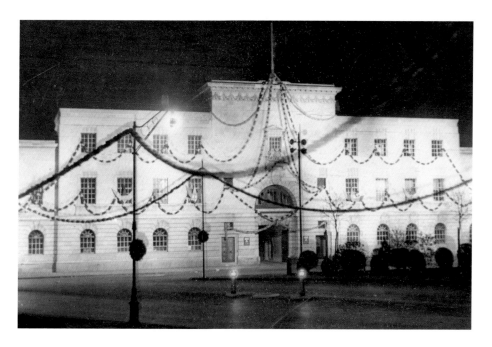

Charles Street Police Station

The police station in Charles Street was designed by G. Noel Hill and opened on 4 September 1933 as the headquarters of the Leicester City Police. It closed in July 2004 and following extensive re-structuring is now part of the Colton Square development providing nearly 10,000 square metres of office space. The last chief constable of the Leicester City Police (before its merger with the Leicestershire force) was (Sir) Robert Mark who later became commissioner of the Metropolitan Police.

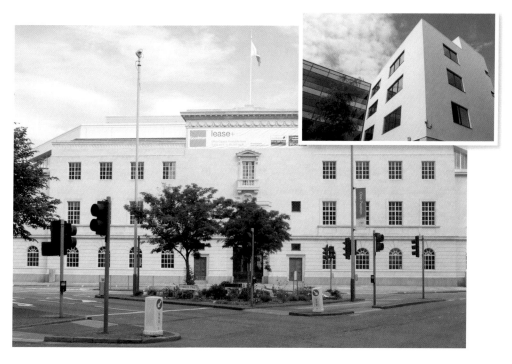

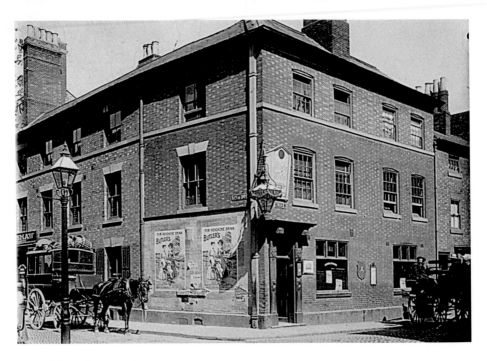

The Globe, Silver Street

A landmark in the old town area since the eighteenth century, The Globe was previously a market house used at the hiring fairs by farmers to recruit their workers for the year. The pub brewed its own beer for many years using spring water from the well in the cellar. It has been owned by the Everard family since Victorian times.

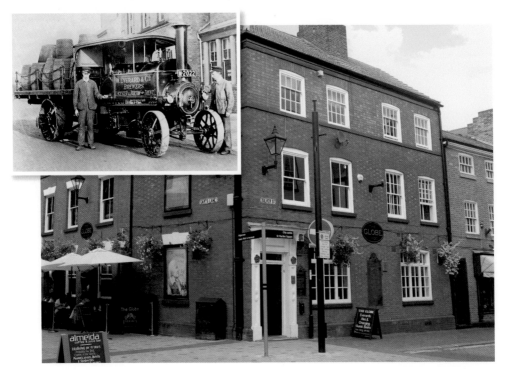

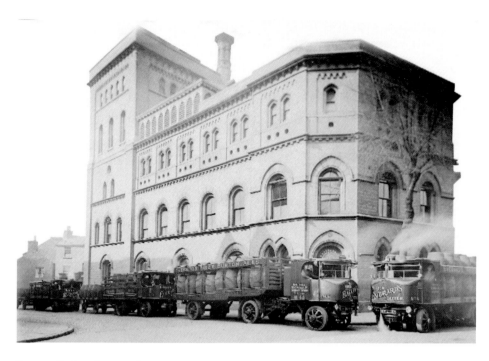

Everard's Southgates Brewery

William Everard brewed his first pint of ale in 1849. His splendid brewery, a proud building, almost Gothic in style, on the corner of Southgate Street and Castle Street, was designed by his nephew John Everard, and opened in 1875, replacing William's first brewery. It closed in 1932 as a direct result of an increase in beer excise duty, which caused Everard's sales to drop overnight by twenty-five per cent. Today, a student hall of residence stands on the site.

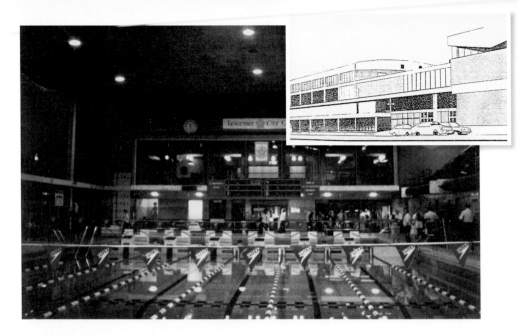

St Margaret's Baths and the Highcross Centre

St Margaret's Baths were built in the 1960s and by the 1990s were in need of major refurbishment and repair. It was the home of the City of Leicester Swimming Club. This photograph shows the interior of the baths ready for a COLSC competition. The site is now within the extensive Highcross Centre. Important remains from Leicester's Saxon period were discovered here during archaeological surveys after the baths were demolished.

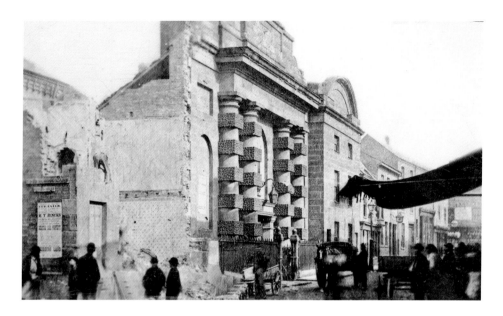

Old Borough Gaol and Freeschool Lane

This rare photograph shows the old Borough Gaol in Highcross Street on the corner of Freeschool Lane, being demolished. There are signs of a market taking place, which may be a remnant of the old High Cross Market. In its place, several small industrial premises were constructed, occupied at various times by William Sutton Ltd, tanners, and the Glenfield Hosiery Company. One small column of the old Gaol's stonework still exists as part of the retaining wall of a Victorian shop.

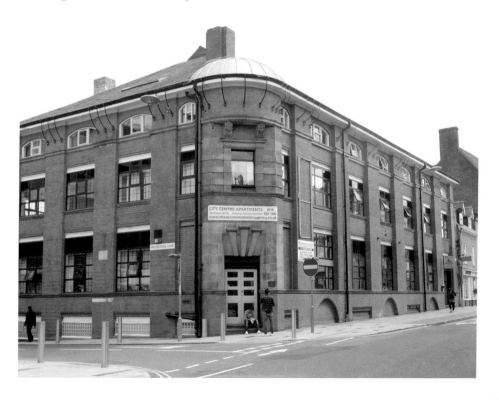

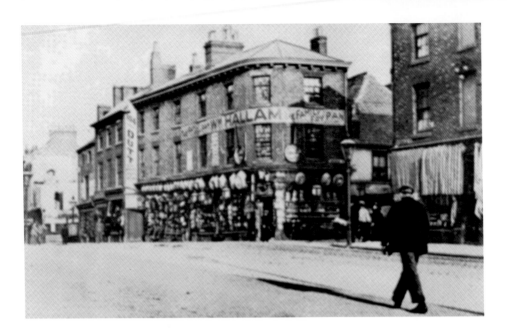

The High Cross

The intersection of Highcross Street and High Street marks the exact centre of the old town. Bricks set into the tarmac of the road indicate where the medieval high cross once stood. There was a cross here as early as 1278 when the borough records indicate it was repaired. This view is looking south from Highcross Street, with High Street to the left. The continuation of High Street to the right of the photograph was formerly St Nicholas Street and is now part of St Nicholas Place.

St Nicholas Place

This building was originally designed as a cheese warehouse for the local company of Swain and Latchmore. In later years it became well-known as Wathes electrical store.

Inset: The Victorian mosaic tiles along the frontage of the building were rescued by the BBC when the building was demolished in 2001 and are now part of the interior of the new BBC Leicester broadcasting centre.

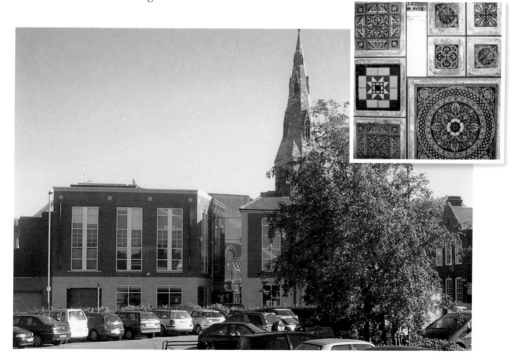

Guildhall Lane

Guildhall Lane was formerly known by many different names including Kirkgate and Kirk Lane in the Middle Ages, and in the nineteenth century it was called Town Hall Lane. At that time the Guildhall served as the town's hall. The earliest part of the Guildhall — the Great Hall — dates from 1390 and was erected as the hall of the guild of Corpus Christi. The Guild was dissolved in 1547 and the Guildhall was sold to the town in the following year.

The Guildhall

The Guildhall is a quadrangle of rooms built in different eras, and over the years many parts of the building have been altered, reflecting its changing uses. It has been the town's police station, library, civic hall and court. Today it is managed by Leicester City Museums Service and is used for concerts, wedding receptions and other public events.

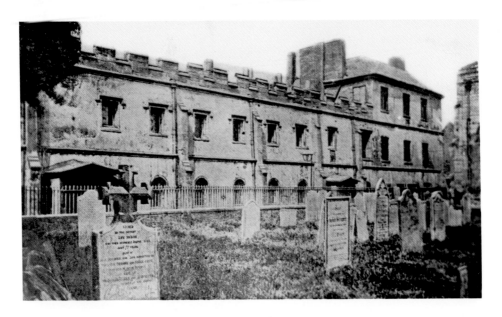

Wyggeston's Hospital

Wyggeston's Hospital, which faced the Cathedral churchyard, was built in 1519 by William Wyggeston, one of Leicester's greatest benefactors. By the nineteenth century the building had deteriorated and was in a state of serious disrepair, and a replacement hospital was built in Fosse Road. There was a determined campaign to preserve the old building by finding a new use for it, but in 1875 it was demolished. Parts of the building and some of the fittings were moved to St Nicholas' church and Trinity Hospital. The rest of the building was sold off by cartload, and the Wyggeston Boys' School was erected on the site. For many years a corner of the school playground, beneath which was the old hospital's chapel and altar, was railed off.

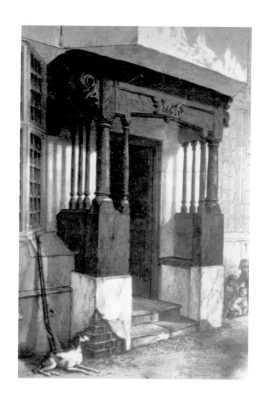

The Nag's Head

This ancient hostelry was one of several buildings on Highcross Street, between Guildhall Lane and Peacock Lane, demolished to make way for the Wyggeston Boys' School, which was built in 1875. The date above the doorway is 1663. The school buildings remain, having been occupied by Alderman Newton's School and, more recently, by Leicester Grammar School. They are now owned by the Diocese of Leicester. The street along the frontage of the school is now known as Applegate.

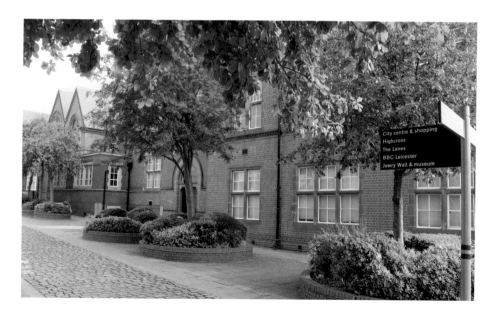

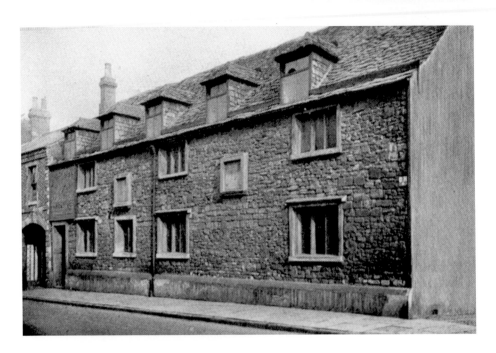

Free Grammar School, Highcross Street

The Free Grammar School was founded by Thomas Wigston, brother of William Wigston. At first the school was housed in the old church of St Peter's (on the corner of West Bond Street and St Peter's Lane — now beneath the Highcross Centre) but in 1573 the corporation voted to demolish it and to erect a new school building using some of the materials from the church and money from the sale of parts of it. Hence the Free Grammar School was built and served as a school for over 300 years. The building was sold in 1860 and has been used for a variety of purposes and business since then, including offices for Barton Buses. In 2008 it was refurbished and integrated very imaginatively into the Highcross Centre.

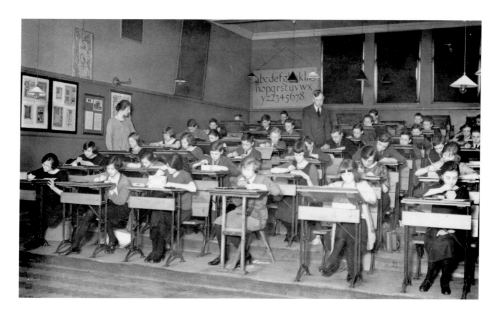

De Montfort University

Leicester's De Montfort University grew out of the former Leicester Polytechnic, which in turn was created with the amalgamation of the Leicester College of Art and the Leicester College of Technology. The Hawthorn Building was built in four stages between 1897 and 1928 for the College of Art. This photograph is of a junior crafts lesson in the Hawthorn Building in about 1923. Over the past decade, De Montfort University has invested heavily in the area of The Newarke, creating a campus with the Hawthorn Building still very much at its centre. The modern Campus Centre is of a dramatically different architectural style.

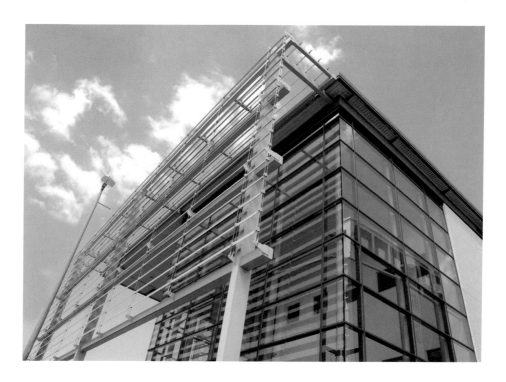

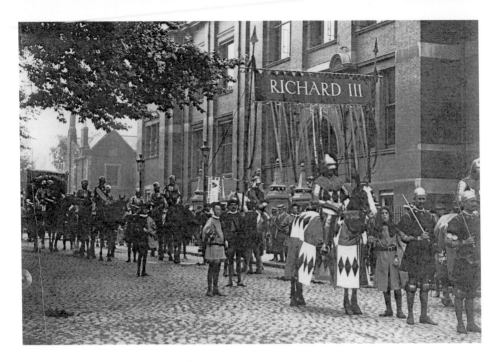

Hawthorn Building and the Leicester Pageant

The Leicester Pageant took place in 1932. It drew together thousands of local people, businesses, schools and colleges and was arguably the largest public event in the town between the two wars. This photograph is of part of the procession that depicted events in Leicester's history, outside the Hawthorn Building. The photograph is significant in that it is probably the work of the artist and photographer George M. Henton who was a student of the College of Art. The costumes for the pageant were designed by the college.

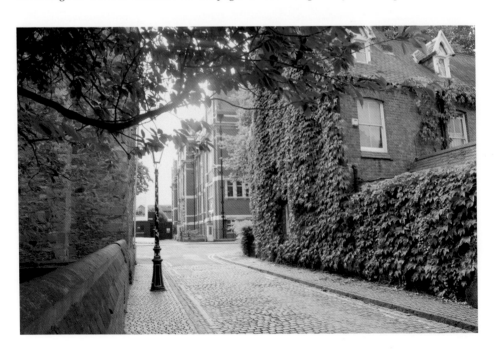

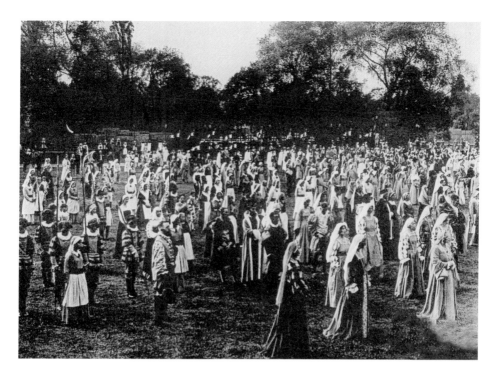

Abbey Park

The Leicester Pageant involved a long and colourful procession. It followed a route that took the hundreds of participants past the town's most significant landmarks. The focal point of the celebrations and displays was Abbey Park, the largest open space in Leicester. Formerly the grounds of Leicester Abbey, the park is one of the greatest assets of the modern city.

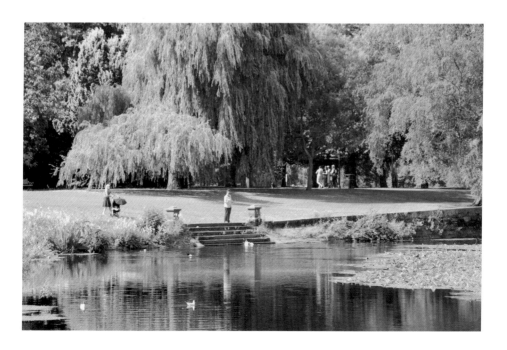

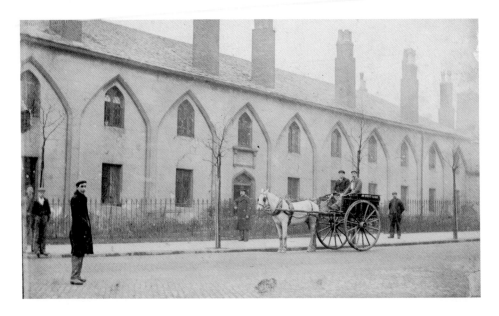

Trinity Hospital

Trinity Hospital was founded in 1331 by Henry, the third Earl of Lancaster and Leicester. In 1352, Henry, the fourth Earl, was elevated to Duke of Lancaster and soon afterwards extended the hospital as part of his plan to create a religious foundation in the Newarke. This very early photograph shows the hospital as it was rebuilt in the 1700s. A fire and alterations in the eighteenth and nineteenth centuries resulted in further changes which included the rebuilding of the final bays of the building on a different alignment to allow for a new road crossing the river. The hospital is still functioning but on a new site. The old buildings are part of De Montfort University.

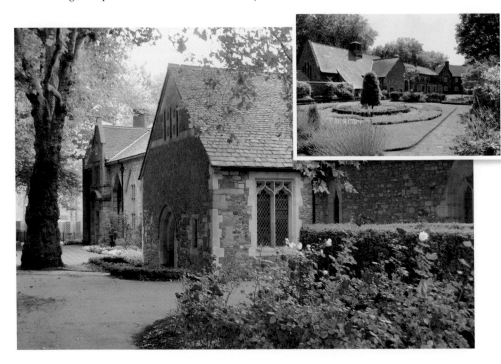

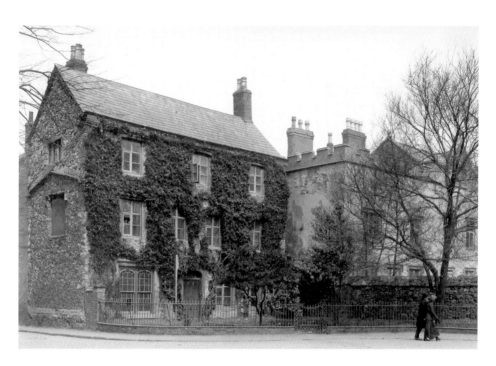

The Chantry House

The Chantry House in The Newarke was built by William Wyggeston in 1512 as a residence for two priests who served at the Chantry he founded in the adjacent Collegiate Church of the Newarke. It is now part of the Newarke Houses Museum. The Wyggeston arms were displayed above the front entrance and can now be seen inside the building.

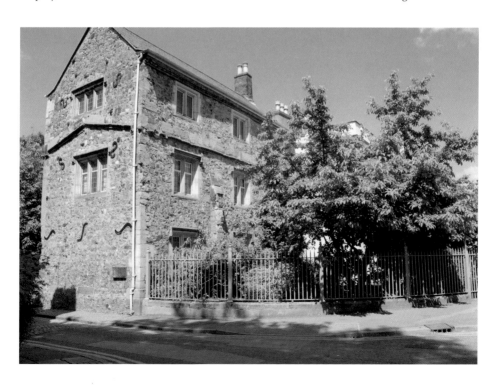

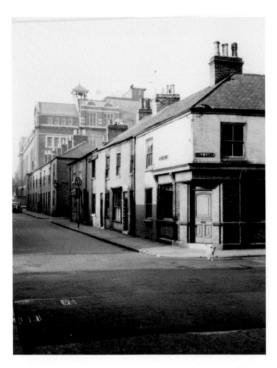

**Asylum Street
now Gateway Street**

This view is of the former Asylum Street, which ran between The Newarke and Mill Lane. It was named after the female asylum, which was situated where the Hawthorn Building stands today and which can be seen in both photographs. In the foreground is Holes corner shop. Today the road is known as Gateway Street, and the Gateway School buildings have taken the place of the corner shop.

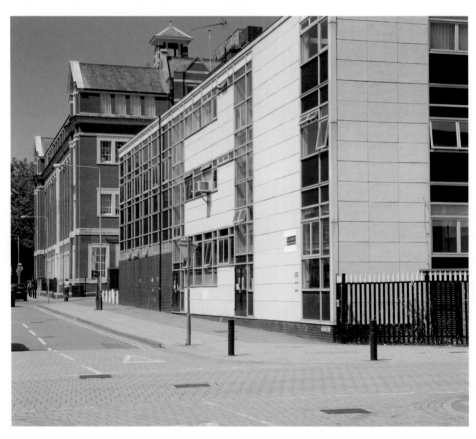

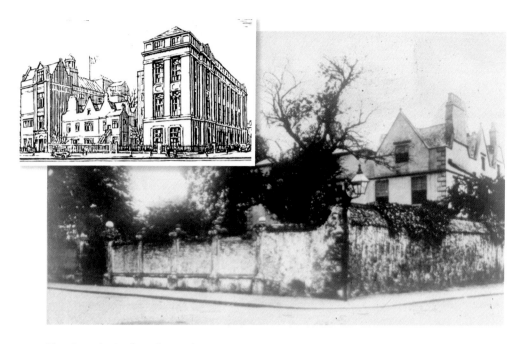

The Female Asylum in Asylum Street

The Female Asylum in The Newarke was established in 1800 'for the maintenance and clothing of sixteen poor girls'. Girls were admitted at the age of thirteen years and stayed for three years during which time they were trained for domestic service. This view is of the junction of The Newarke and the then Asylum Street. The Hawthorn Building of the College of Art was constructed in stages and for some years in the early nineteenth century almost surrounded the old asylum. The final wing was built in 1935 by which time the asylum had been demolished.

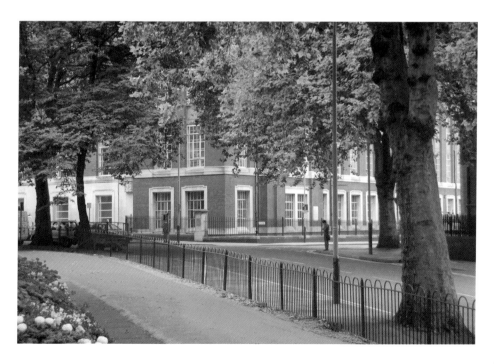

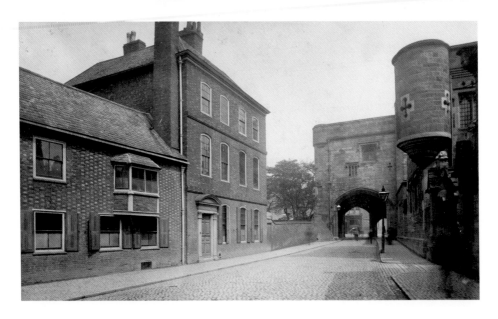

The Newarke and Magazine Square

This ancient site has changed beyond recognition over the past century. The only survivor from medieval times is the Magazine Gateway, built in the very early years of the fifteenth century as an entrance to the Newarke. The military drill hall buildings were built adjoining it in 1898, but have since been demolished. In the 1960s Leicester Polytechnic, now De Montfort University, erected the James Went building which was demolished in the early years of the twenty-first century. In 2009, the university built its new business and law building on part of this site — named the Hugh Aston Building after the Director of Music at the Collegiate Church of St Mary of the Newarke, which is located near to this site and was destroyed after the Reformation. The modern photograph is a view from near the castle, towards Prince Rupert's Gateway (the other surviving entrance to the Newarke), with the Hugh Aston Building visible above.

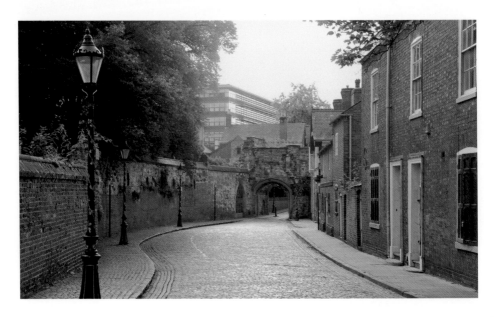

Magazine Square Mosaics and the James Went Building

Many buildings of the 1960s were constructed before the chemical properties of concrete were fully understood. Consequently, some have had to be demolished because of structural problems; the James Went building suffered this fate. It stood in Magazine Square, dwarfing the surrounding buildings. James Went was the first headmaster of Wyggeston Boys' School and his contribution to education continues to be recognised in a new wing of the Wyggeston and Queen Elizabeth I College which has been named after him. In the 1970s, Leicester City Council commissioned artist Sue Ridge to design colourful mosaics to adorn the Newarke Subway walls linking the city with the Newarke. Her designs were brought to life by ceramics expert Christopher Smith. Sadly, these mosaics were sacrificed as part of the modernising of the Magazine Square.

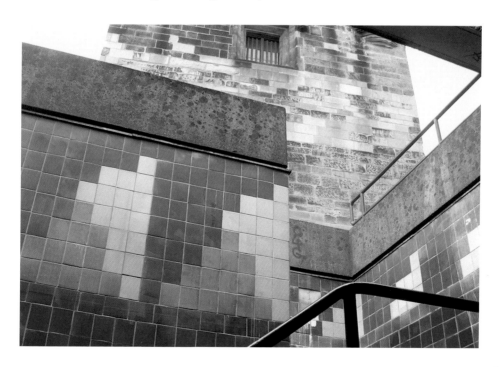

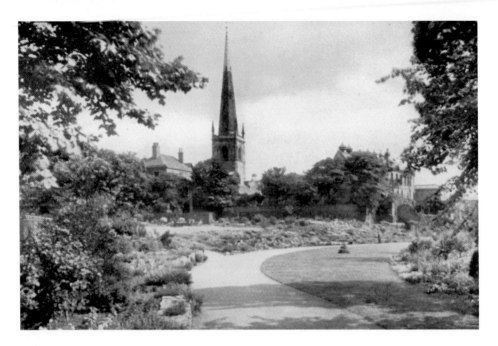

St Mary de Castro

St Mary de Castro, with its slender spire, stands above the River Soar. It was founded in 1107 by Henry I, possibly on the site of an even earlier church. It is rumoured that here, around 1366, Geoffrey Chaucer married Philippa de Roet, a lady in waiting to Edward III's queen, Philippa of Hainault, and sister of Katherine Swynford, who later became the third wife of Chaucer's good friend and patron John of Gaunt. Henry VI was knighted in the church in 1426.

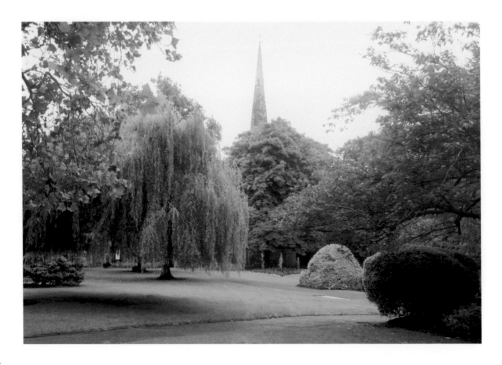

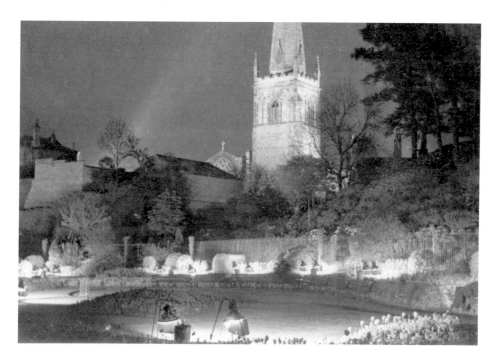

St Mary de Castro and Castle Park

Most visitors approach Leicester by road or by rail, so the significance of its location by the side of the River Soar is not appreciated. The river and the land rising above it certainly offered a defensive position for the castle and its church. After the industrial revolution, mills and factories lined the river, which was canalised to prevent flooding. Today, many of these buildings have been converted into residential accommodation and new footbridges give access to Castle Park.

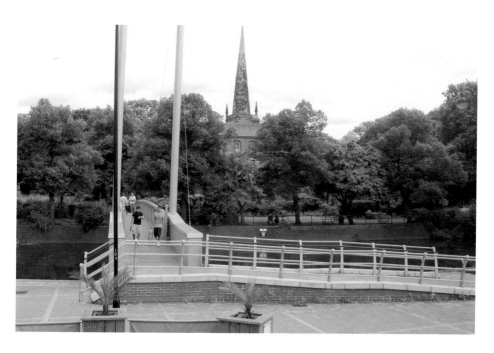

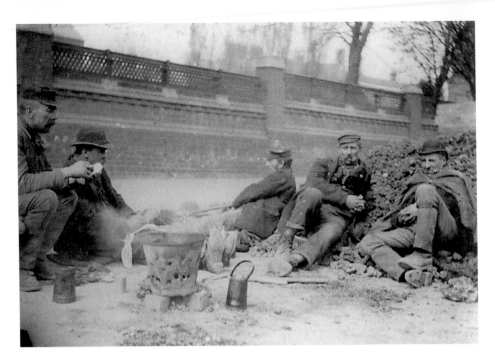

West Bridge

Above is a delightful photograph of workers resting whilst rebuilding West Bridge in 1899. It replaced a bridge built less than sixty years before which had proved incapable of coping with the increased traffic entering the town. Today, West Bridge and Bow Bridge provide a vital commuter link into the city from the Midlands motorway network.

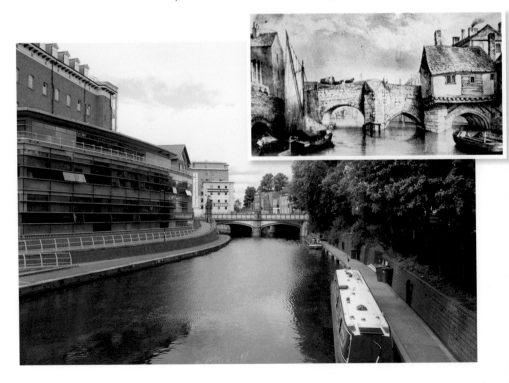

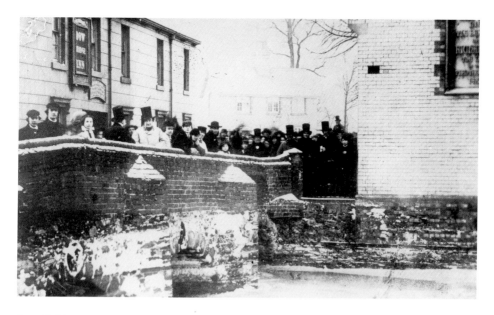

Bow Bridge

The above picture shows a civic event, possibly the re-opening of bridge. The name is due to its location near to the old Augustinian Friary, which erected a simple arched footbridge in the shape of a bow. It is also famous as being, in legend, the bridge across which the body of Richard III was brought after the Battle of Bosworth in 1485. During 2009, the bridge (which is not at the same location as its predecessors) has been rebuilt once more to cope with twenty-first century road traffic.

Inset: the strong association with Leicester, the Bow Bridge and Richard III is perpetuated in this superb statue that stands close to the modern bridge.

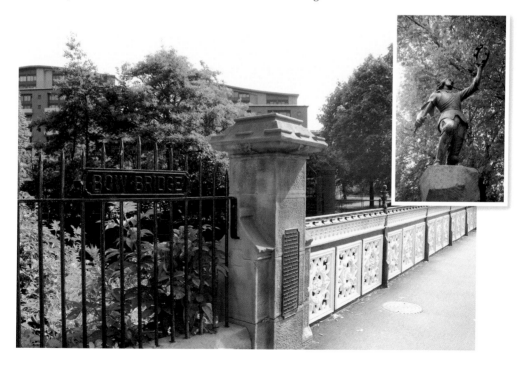

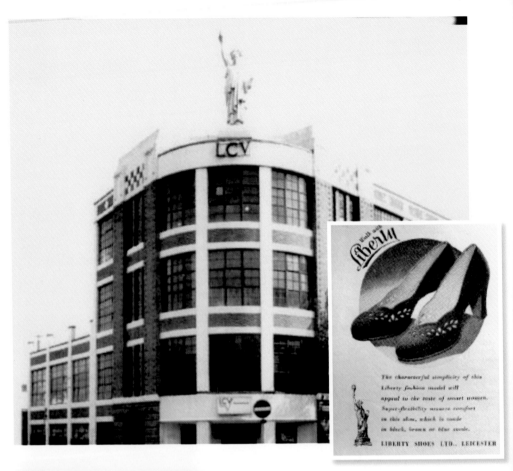

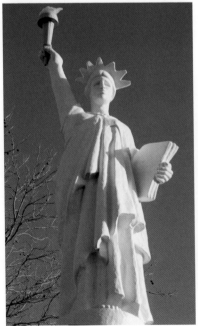

The Liberty Statue

Sculptor Joseph Morcom created the Liberty Statue in his works in the Newarke behind the present museum buildings. Lennards Shoe factory was built on the corner of Eastern Boulevard and Upperton Road in 1919. The directors had been impressed by the original Statue of Liberty during a visit to New York in 1920. Until the 1990s she stood above the factory and after its demolition she was placed in storage. She was publicly revealed in her new home on the Swan Gyratory roundabout in December 2008.

Inset: So popular was the Liberty image that Lennards decided to market their shoes with the 'Liberty' tag.

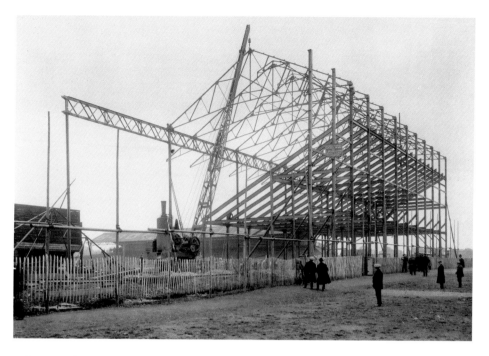

Leicester City Football Club — The Walkers Stadium

Eighty years separate these two images. The design of football grounds has changed fundamentally, but beneath each stand is a skeleton of steel girders. The early photograph is of the main stand being erected at Filbert Street in 1921. The Walkers Stadium, in the shadow of Filbert Street, opened in July 2002. By the 1990s Filbert Street looked so outdated that Martin O'Neill, when Leicester's manager, once joked that when he showed Filbert Street to new signings he led them backwards out of the players' tunnel to prevent them from seeing the east stand!

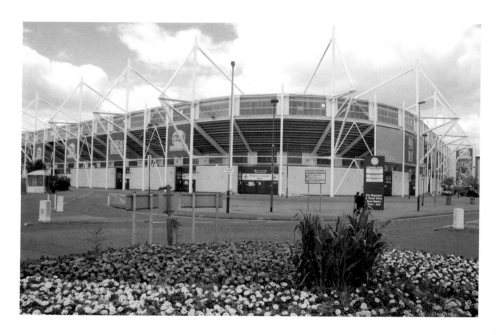

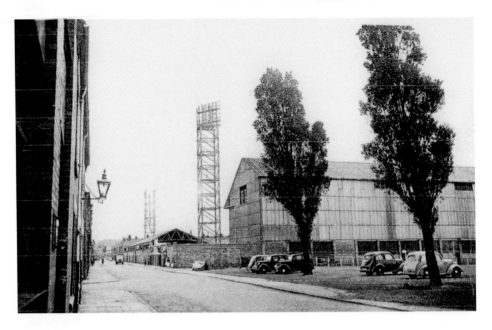

Filbert Street — New Floodlights

Modern technology came to Filbert Street in 1957 with the erection of floodlights. The trees have grown in the intervening half-century, and the first stage of the new Filbert Village stands where fans once cheered their team. The electricity supply for the floodlights was presumably guaranteed as it was generated next door where the Walkers Stadium is now located.

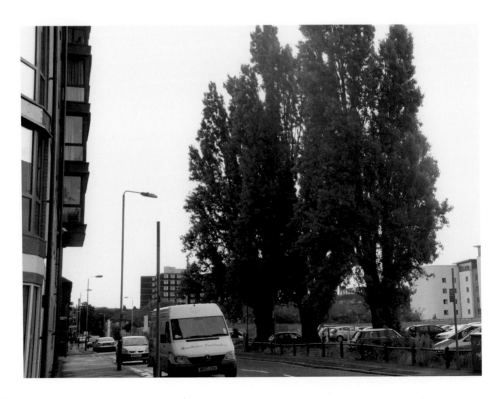

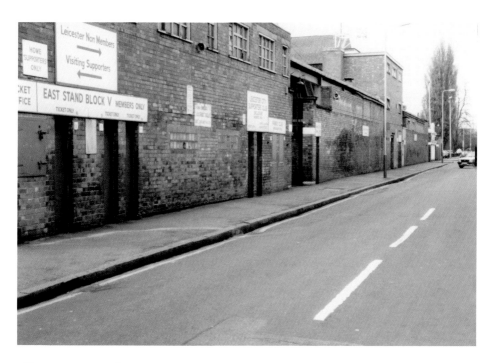

Filbert Street — The East Stand

A view that will be familiar to all Leicester City supporters: the east stand façade facing Filbert Street. The two blue gates and the street lamps in the distance are all that remain. The road turning to the left is named 'Lineker Way'.

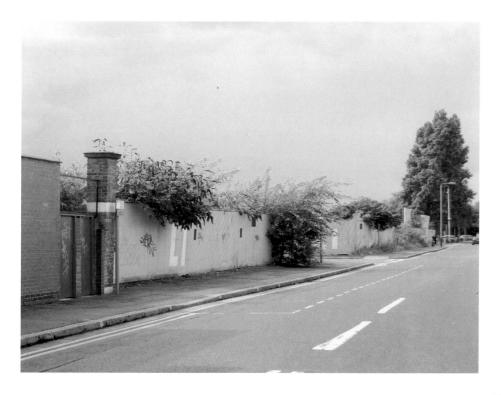

Filbert Street — Towards the LRI

The buildings of the Leicester Royal Infirmary cast a shadow over the end of Filbert Street in both these photographs. The nearest building on the left has been demolished, but the Victorian terraced houses remain. Today they look across a derelict building site.

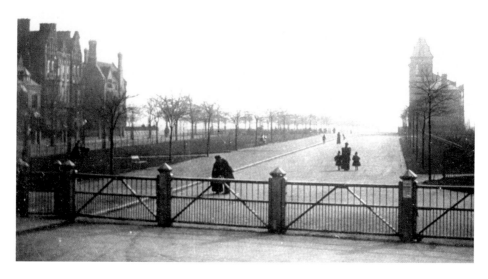

Victoria Park

Victoria Park was once Leicester's racecourse and this early photograph has echoes of that time. The park was laid out in 1883. Today the promenades are not so obvious, due to later landscaping and tree planting. One of the towers of Leicester University's campus rises in the background.

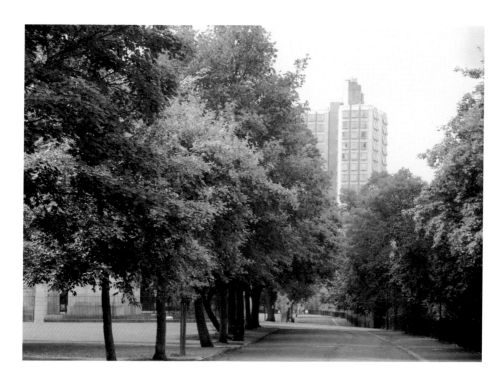

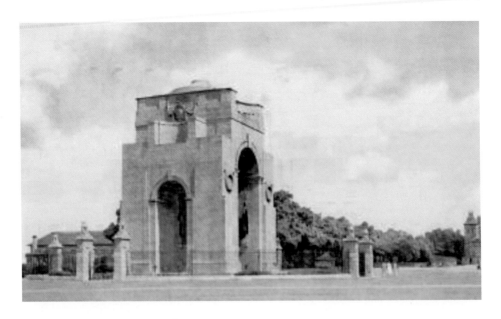

War Memorial, Victoria Park

The War Memorial in Victoria Park was designed by Edwin Lutyens and built in 1923. It is a Grade I listed building, which stands at the top of an ornamental walkway called Peace Walk, with gates also by Lutyens installed in 1930. A smaller memorial nearby commemorates the role of the American 82nd Airborne Division, which was stationed in Leicester prior to D-Day.

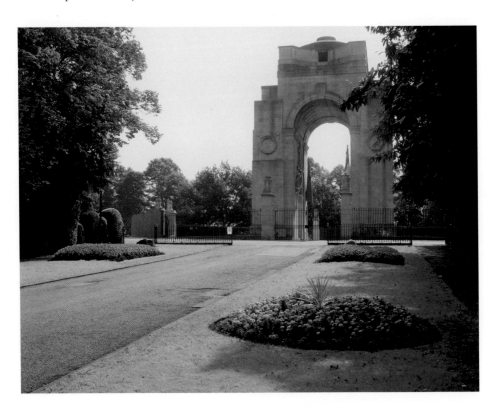

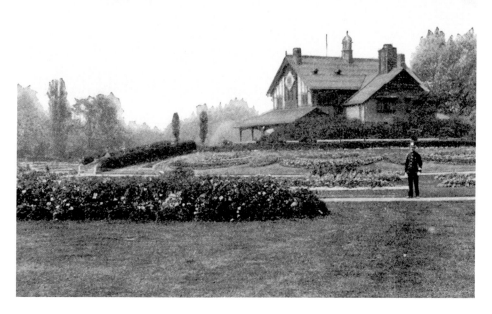

Abbey Park

A park keeper in uniform stands beside some of the extensive flowerbeds next to the old pavilion in Abbey Park. The park was extended in 1925 when the abbey grounds were added. The bridge over the river, which leads to the modern café, links the two areas.

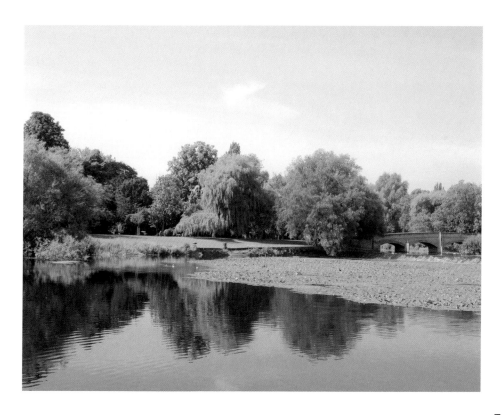

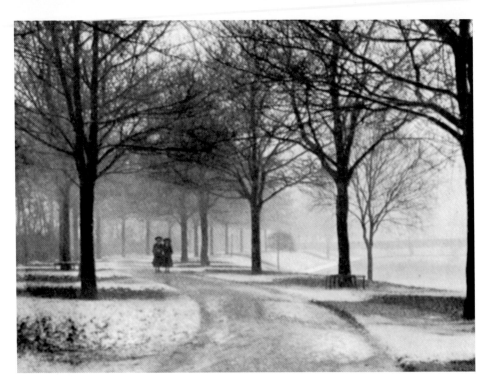

Abbey Park

Two ladies enjoy the crisp fresh air of Abbey Park after a snowfall in the winter of 1910. A competition for the design of the park was held in 1877 and won by William Barron of Derby who opted for natural landscaping with long curving paths. James Tait, a local architect, designed the buildings and gatehouses of the park.

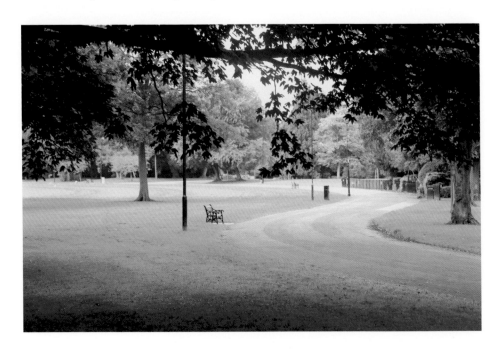

Abbey Park — Cavendish House Ruins

Cavendish House was built by the Marquis of Northampton using material from the ruined abbey. In 1613, William Cavendish, the first Earl of Devonshire, acquired the property and it became known as Cavendish House. It was used by Charles I after the siege of Leicester in 1645. After he left, his soldiers set fire to it, and left the building gutted. Charred stone window frames can still be seen today, even after more than 350 years of exposure to the elements.

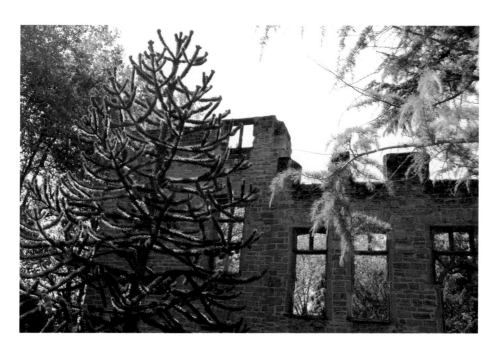

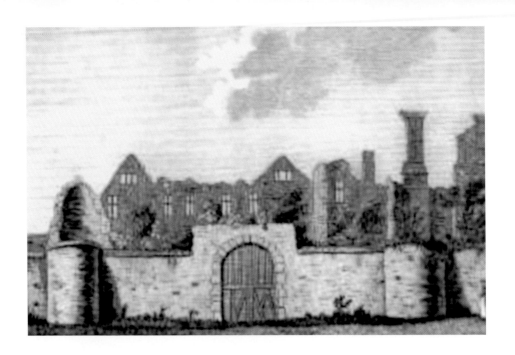

Abbey Park — Cavendish House Ruins

This very early drawing of Cavendish House shows some of the abbey ruins still standing above ground. The plundered stone from the abbey was used again in the nineteenth century to build the house that stands today on part of the site. The gateway of Cavendish House probably occupies the site of the original entrance to the abbey.

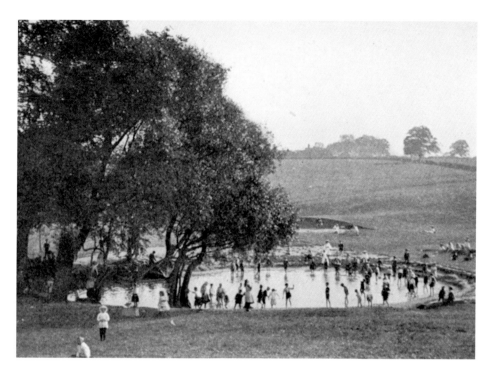

Western Park

Western Park was laid out in 1897, and this small lake was part of the landscape design. The lake has survived, though reduced in size, as part of a children's play area. As well as the more traditional and sedate park activities, Western Park also has a BMX cycle track and an 'eco house' demonstrating new methods of energy conservation.

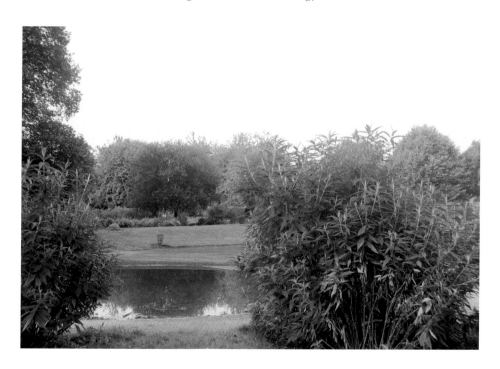

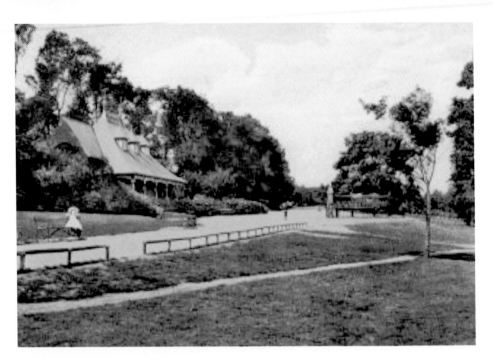

Spinney Hill Park

Spinney Hill Park was created by Leicester Corporation in 1885 from land purchased for the purpose. This photograph is dated 1912 when the pavilion and pathways were still looking new. It was designated a conservation area in 1982. Local residents work with the council to maintain the park and there is an active gardening society involved. Today the tall mature trees add to the sense of calm and tranquillity.

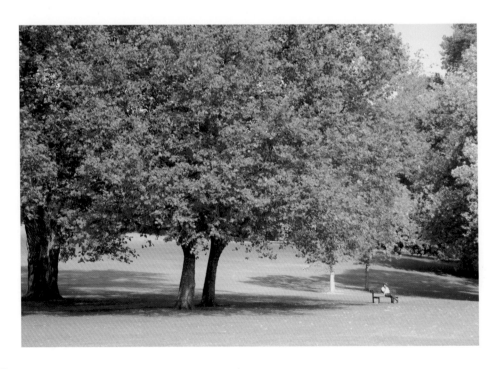

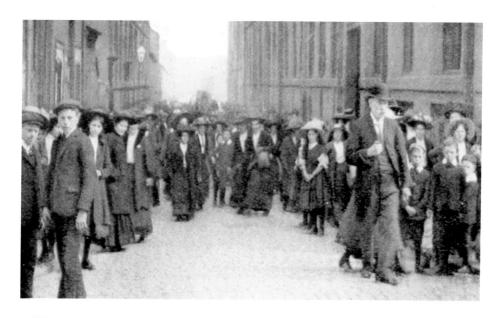

William Raven & Co. Hosiery Factory, Wharf Street

The photograph above shows workers leaving Raven's Hosiery in Wheat Street. The extensive premises flanked both sides of Wheat Street, extended to nearby Crafton Street and also faced onto Wharf Street. Politically, Raven was a Liberal, and he was also a Unitarian. From humble beginnings he created a business, which by the time of the First World War was employing 1,000 people. The company continued trading until the 1960s under the 'Ravena' and 'Craftana' brand names. Next door was the Prince of Wales public house, now a coffee bar. The two factories on either side of Wheat Street remain.

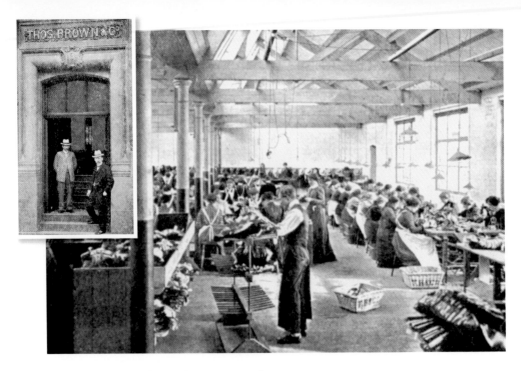

Thomas Brown Ltd, Humberstone Road

Thomas Brown's textile manufacturing empire occupied a huge area along Humberstone Street and adjacent Nedham Street, but hardly any building has survived except this gaunt warehouse behind today's modern buildings and near to the railway lines running into the London Road Railway Station.

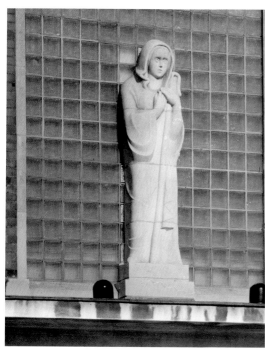

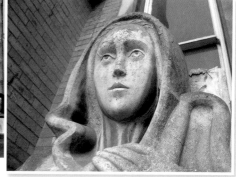

The Corah Statue of Saint Margaret

Nathaniel Corah and Sons patented their image of St Margaret in 1875, ten years after the company began production on the site near St Margaret's church. It was a most appropriate symbol for a company producing garments from wool, as Margaret was a shepherdess. After Corah's closed in the 1900s, the statue was removed and was placed inside the factory's main quadrangle. She has now been relocated to St Margaret's church.

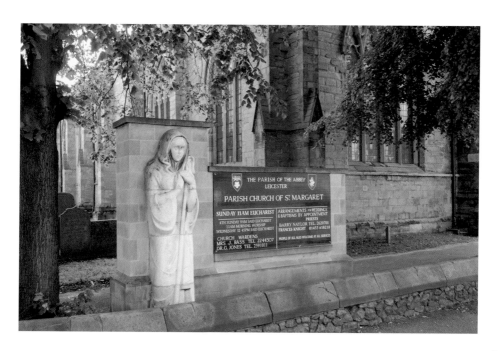

Corahs, St Margaret's Factory

Born in 1777, Nathaniel Corah was a framesmith and whilst still in his twenties he established a small textile business in the Leicestershire village of Barlestone. In the nineteenth and for most of the twentieth century the company he founded was Leicester's leading textile manufacturer. It was the first textile company to adopt production management and quality control and also the first to build a factory with integral steam-derived power. They were the first textile firm in Leicester to install electric lighting and the first in the country to give workers an annual paid holiday. The impressive quadrangle inside the St Margaret's factory still stands, and it is now home to a variety of small businesses.

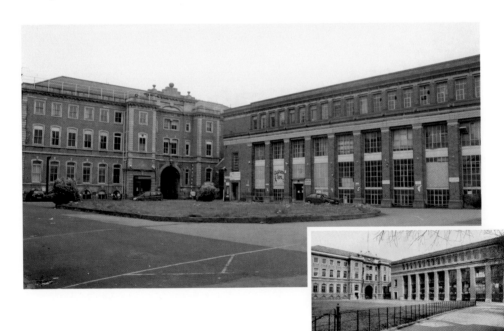

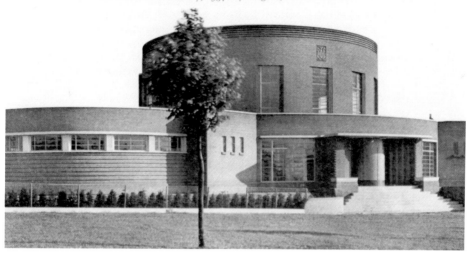

Pork Pie Library, Southfields

The Southfields Library was built in the 1930s and won an award for its designers. It is now a Grade II listed building. Amongst its internal features was a well-equipped film projection facility. It was refurbished in 2007 but is scheduled to close by 2012 to make way for a multi-purpose community centre that will include a new library. The old building will be retained and Leicester City Council is working to find a new use for this iconic landmark.

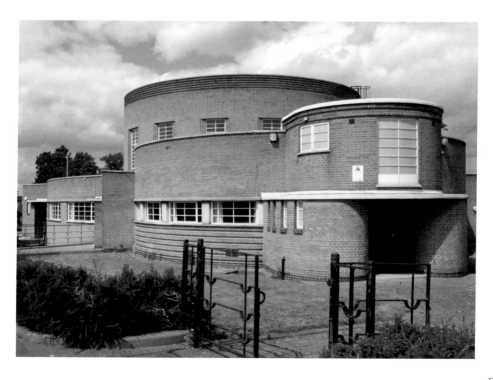

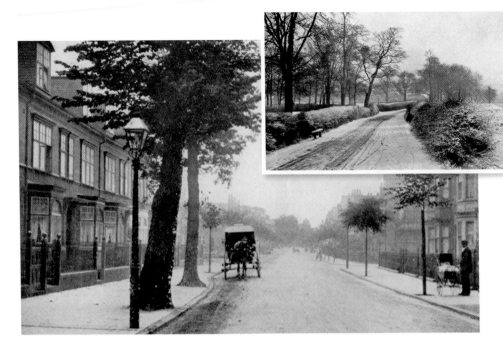

Fosse Road South

A long road with an equally long history, Fosse Road connects the heart of the city with the housing areas of Braunstone. Leicester City Football Club was founded in 1884 as Leicester Fosse because their first ground was nearby. Fosse Road was developed over many years, so whilst the buildings nearer the city centre are early Victorian the later developments date to the mid-twentieth century.

Inset: In the Victorian period, Fosse Road led into the countryside. The area is now occupied by the Braunstone Estate.

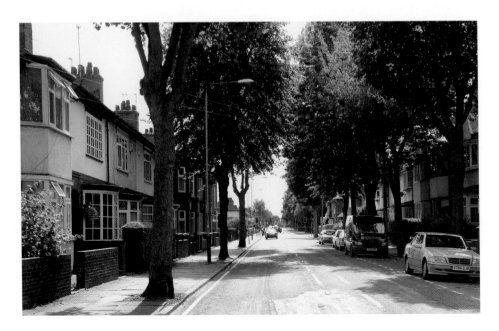

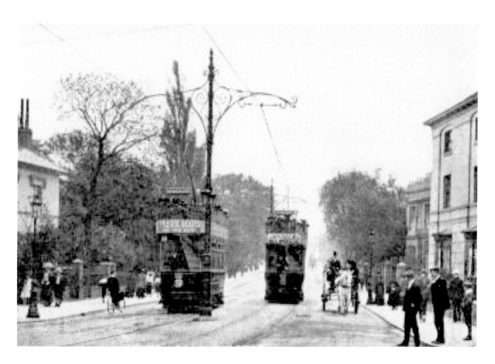

The London Road

Apart from the electric trams there is almost a village atmosphere in this view of London Road in the nineteenth century. A major route into the city today from Market Harborough and the Outer Ring Road, bus lanes have replaced the tramlines; the leafy tranquillity of this turnpike can still be seen early in the morning before the daily rush hour commences.

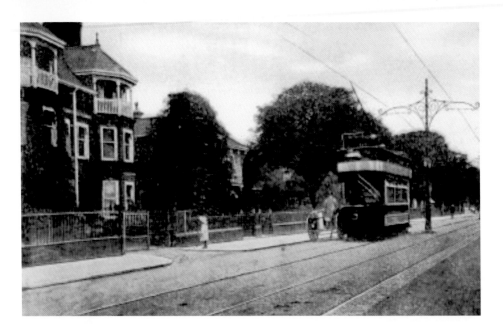

London Road and Trams

London Road connected the town with the desirable suburb of Stoneygate where many of Leicester's leading businessmen lived. There are still many examples of the work of Leicester's finest architects in the area and on the quiet roads leading into London Road. Adjacent are the University of Leicester's Botanic Gardens, created by merging the gardens of four of the big houses in the area.

Inset: The tram terminus was near to the modern junction with the Outer Ring Road. The tram shed remains next to a modern service station.

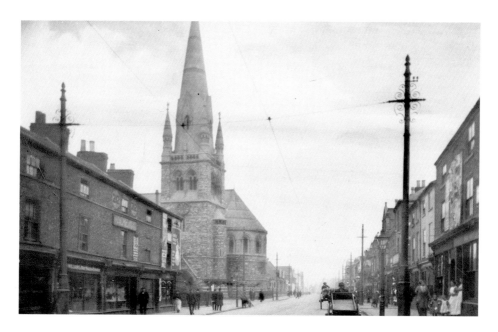

St Mark's, Belgrave Gate

Still dominating Belgrave Gate, St Mark's was built in 1870-2 to designs by Ewan Christian, and the costs were met by W. Perry Herrick of Beaumanor. The church is built of Charnwood slate with the interior lined in red brick. Its most famous vicar was Canon Frederick Lewis Donaldson, described as the 'vicar of the unemployed', and one of the leaders of the 1905 unemployed march to London. He commissioned remarkable wall paintings from the Arts and Crafts artist J. Eadie Reid, which are still in the church today. The building is now used as a restaurant.

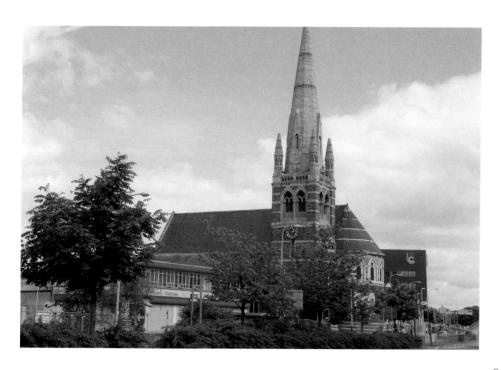

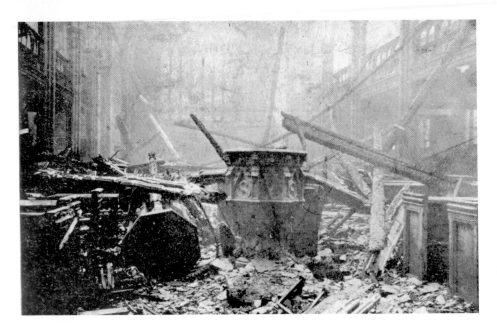

St George's Church

St George's church was built in local sandstone between 1823 and 1827 to a design by William Parsons. It was the first Anglican church to be built in Leicester since the Reformation. The chancel was added in 1879. A fire devastated the church in 1911 and it was largely rebuilt by W. D. Caroe. It has been used as a place of worship for Serbian Orthodox Christians since the 1970s.

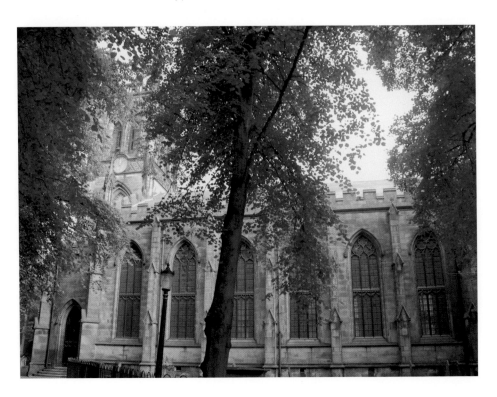

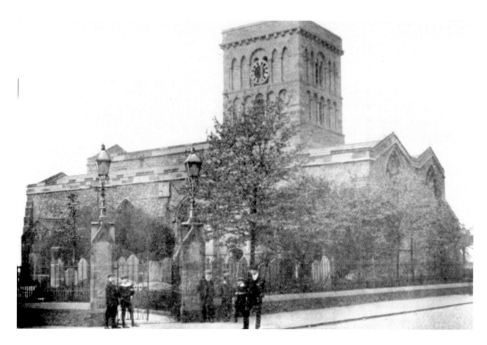

St Nicholas' Church

Leicester's oldest place of worship, probably built on the site of the basilica of Roman Leicester. A church existed here before the present building, which suggests that this has been a place of Christian worship for at least 1,400 years. Part of the churchyard was taken for street-widening in 1898, and in the 1970s this ancient building found itself in close proximity to the Central Ring and St Nicholas Circle developments, thus changing its environment for ever. This modern view is from what remains of Holy Bones that formerly continued to its junction with St Nicholas Street, approximately where the Holiday Inn is located today.

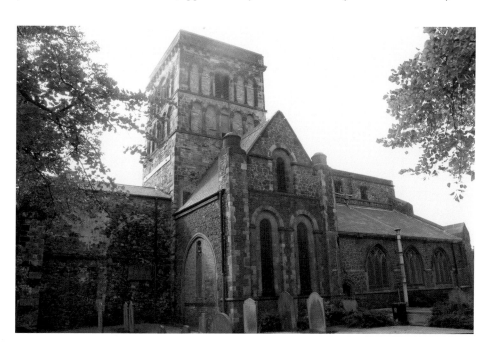

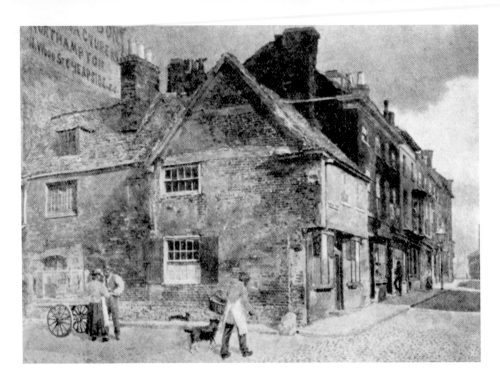

Redcross Corner

It is difficult to confirm the precise location of this sketch by the Leicester artist and photographer George M. Henton. Henton described this view as the corner of Redcross Street and Highcross Street. Redcross Street vanished in the redevelopment of this area during the 1970s. This modern view is looking along Highcross Street (as it was in Henton's time) from its intersection with Peacock Lane and the former Wyggeston Boys' School on the right. The derelict Victorian warehouse would seem to be on the site of Henton's old building.

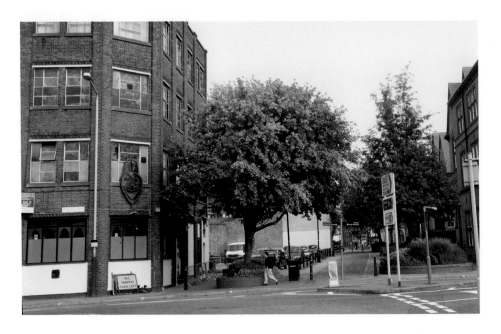

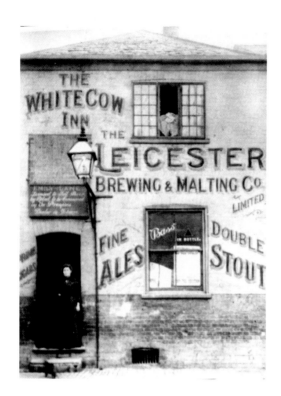

The White Cow, Willow Bridge Street

Emily Lane, licensee of the White Cow in Willow Bridge Street, standing outside her hostelry in 1907. The pub was near the corner of Russell Square. Despite generations of redevelopment, part of Calgary Road on the St Matthew's Estate still follows the original line of Willow Bridge Street.

Inset: the path of the old road can also be seen at the end of the football pitch between Willow Street and Dysart Way.

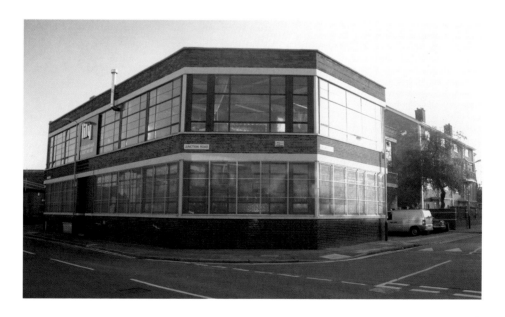

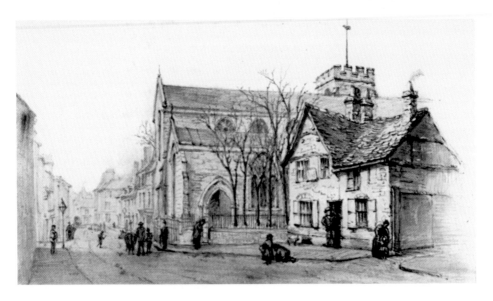

All Saints' Church

All Saints' is one of Leicester's oldest churches, standing on the ancient road that led north out of Leicester. The earliest part of the surviving fabric dates to the twelfth century. This early drawing shows the church as dominant within the local landscape but by the nineteenth century it had become surrounded and over-powered by factories. These in turn have become largely redundant, and now the new multi-storey car park connected to the Highcross Centre is just a few minutes away from the churchyard.

Inset: this fascinating clock that had two Jacobean figures striking the bell on the hour was originally above the west door of the church and was moved to the south door when restored in 1899. It is presently being restored again.

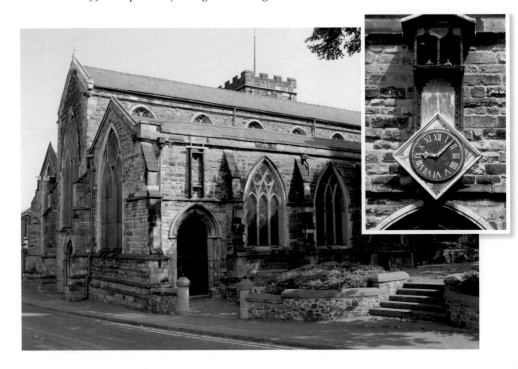

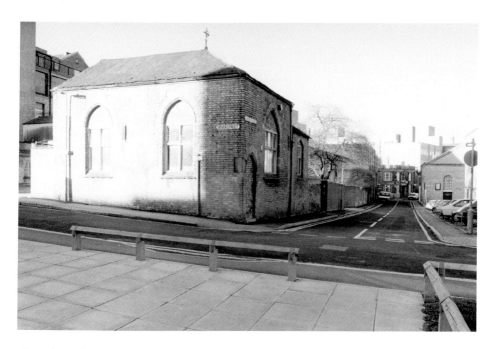

Chapels and Mosques

Leicester has a long history of respecting religious freedom. There were many nonconformist chapels in the town and dissenting preachers. This little chapel in Dover Street, once the St John's Infants' School, has now gone although the Gospel Hall in nearby York Street (in the distance on the right of this photograph) is still very active. Over the past thirty years, incoming communities from Asia and Africa have brought new faiths to the city and new styles of architecture. This is the Mosque in Berners Street.

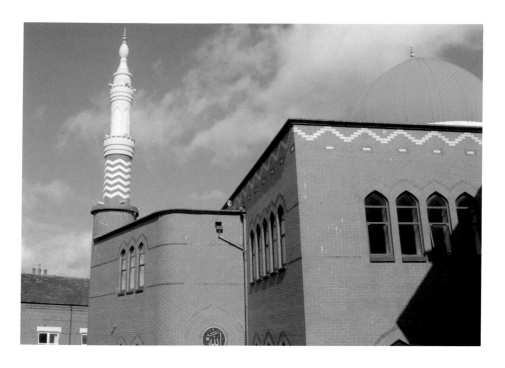

Acknowledgements

Many local people and businesses have assisted in my search for photographs that capture the essence of Leicester's past. I would like to acknowledge in particular, Linda Butt, archivist at De Montfort University, Micky Sandhu of Everards Brewery Ltd, John Hutchinson and the management team of Leicester City Football Club, Carole Lister and the City of Leicester Swimming Club, Brian Rowe and the staff and volunteers of the Great Central Railway and Neil Brown in New Zealand.

The historic Guildhall as seen from Guildhall Lane in early morning sunlight.